PUTNEY & ROEHAMPTON

THROUGH TIME

Simon McNeill-Ritchie
& Ron Elam

AMBERLEY

Acknowledgements

The sources of information for this book include Dorian Gerhold's *Putney and Roehampton Past, Putney in 1636: Nicholas Lane's Map, Villas and Mansions of Roehampton and Putney Heath* and *The Putney Debates 1647*; *Putney & Roehampton (Britain in Old Photographs)* by Don Hewson; *Putney and Roehampton* by Patrick Loobey; *Picture the Past: The Way We Were*, Vol. 3, by Anthony Shaw; and Putney Library.

The authors would also like to thank Dorian Gerhold, Berni Griffiths and St Mary's church, Adam Jastrzebski, Richard Lo and David and Victoria Nicholson.

For my parents

For my wife, Hazel and my children, Annalise and Jon

First published 2015

Amberley Publishing
The Hill, Stroud, Gloucestershire, GL5 4EP
www.amberley-books.com

Copyright © Simon McNeill-Ritchie and Ron Elam, 2015

The right of Simon McNeill-Ritchie and Ron Elam to be identified as the Authors of this work has been asserted in accordance with the Copyrights, Designs and Patents Act 1988.

ISBN 978 1 4456 4738 8 (print)
ISBN 978 1 4456 4739 5 (ebook)

British Library Cataloguing in Publication Data.
A catalogue record for this book is available from the British Library.

Typesetting by Amberley Publishing.
Printed in Great Britain.

Introduction

In a general election, year that has also marked the 800th anniversary of the Magna Carta and celebrated Queen Elizabeth II becoming the longest-reigning monarch in British history, it seems singularly fitting to publish the latest in the *Through Time* series about Putney. For over a few days in late 1647, both officers and common soldiers of Cromwell's New Model Army discussed as equals the future of British government in what have become known as the Putney Debates. The venue was St Mary's church, which still stands at the bottom of Putney High Street beside the bridge, and which features prominently in the pages of this book.

At the time, Putney was a small town of fewer than 1,000 inhabitants. Some of the reasons it was chosen as the venue for the debates are the same ones that draw residents to it today. Perched on the southern bank of the River Thames, it was easily accessible by land and water. Just 5 miles from central London Putney was also home to wealthy merchants who maintained rural retreats in and around the town, which made ideal billets for the officers attending the debates.

The first permanent bridge over the Thames between Putney and Fulham had established a good road link into central London from 1729, but the area remained largely agricultural. It was the arrival of the railway line to Waterloo in 1846, followed four decades later by a new stone bridge over the river and the extension of the District Line, which made Putney highly desirable to wealthy and middle-class commuters employed in central London. Many of the streets and much of the housing we see today dates from then.

Nevertheless, as one travel writer observed at the start of the twentieth century, Putney continues to be:

> One of the pleasantest of the London suburbs, as well as the most accessible. The immense increase in the number of houses in late years testifies to its popularity; but there is still an almost unlimited extent of open ground which cannot be covered; and with wood and water, common and hill, there will always be an element of freshness and openness in Putney seldom to be obtained so near London.

Lying on the south-western borders of Putney, Roehampton was just a small village. More so than its neighbour, the development of Roehampton was initially built around a number of large private estates, several of the original large houses of which survive today. Roehampton village itself retains some of its earlier historic charm, but more widely the area was dramatically transformed with the building, firstly, of the Roehampton estate (later renamed the Dover House Road estate) in the 1920s and 1930s, and more latterly of the Alton estate, in the 1950s, which is one of the largest council estates in the UK.

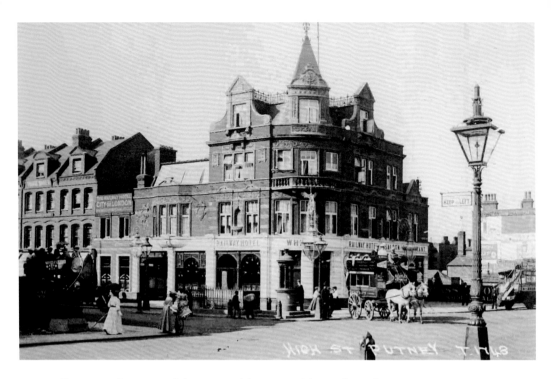

Railway Hotel, Putney High Street with Upper Richmond Road

The Railway Hotel was built in 1857, eleven years after the station opposite opened in the mid-nineteenth century. Street lighting was generally poor in Victorian times and it was not unusual for pubs to provide lighting outside their building to attract customers, hence the large lights at the corner and on each side. While the hotel was built to serve rail passengers travelling through Putney, its neighbours today accommodate the needs of those who want to stay longer, with no fewer than seventeen estate agents in the immediate vicinity!

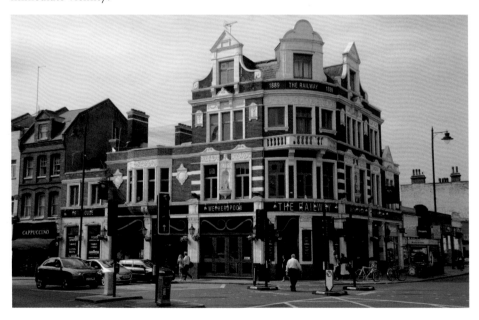

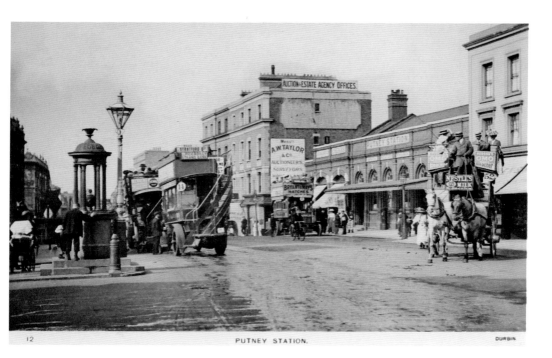

PUTNEY STATION. DURBIN

Railway Station, Putney High Street

Putney railway station opened on 27 July 1846 when the Nine Elms to Richmond line was put into service. It was rebuilt forty years later with double the number of tracks. The present building is late Victorian and stands on a bridge over the railway tracks, which also supports the high street in front of it.

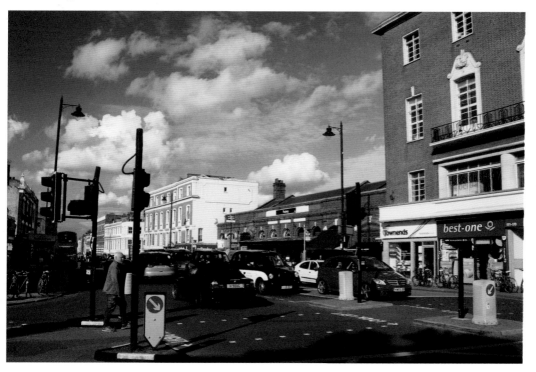

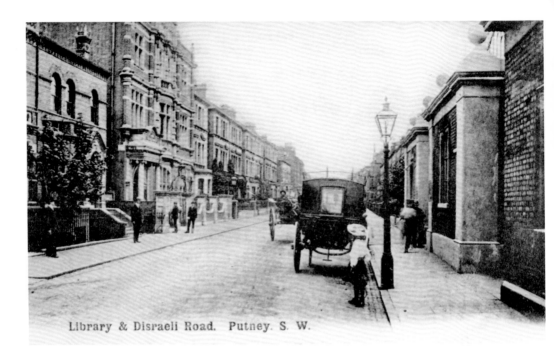

Library & Disraeli Road. Putney. S. W.

Newnes Library, Disraeli Road
Disraeli Road was built in the 1860s. It was named after the former Conservative Prime Minister, to which at least one liberal-minded resident rather illiberally took offence by tearing the street name from the house to which it was affixed, for which he was then fined. The publisher Sir George Newnes, baronet of Wildcroft on Putney Heath, donated the public library on the left. It was opened in 1899.

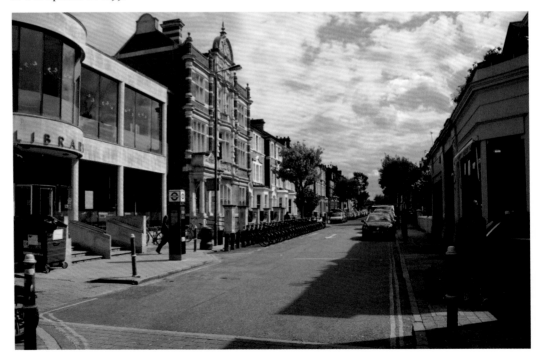

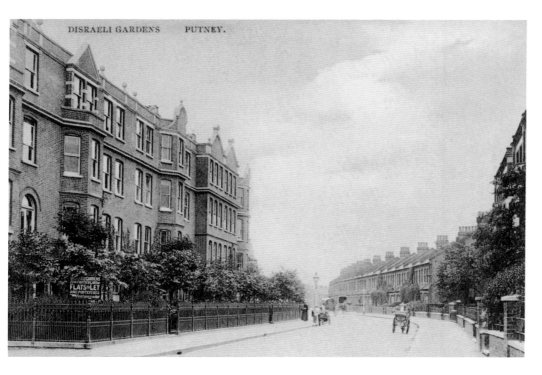

Disraeli Gardens

This prestigious mansion block development on the corner of Bective and Fawe Park Roads also houses beautiful communal gardens and tennis courts. Note the two carts each bearing a churn of milk, being poured into metal containers and delivered door to door.

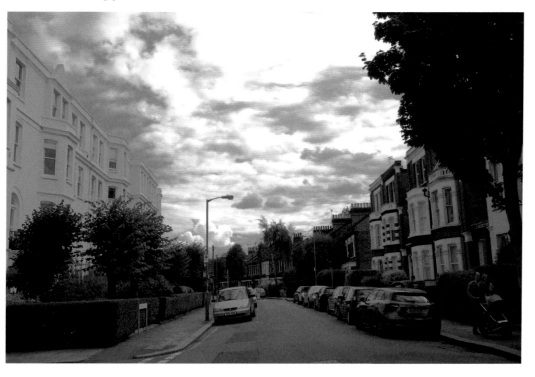

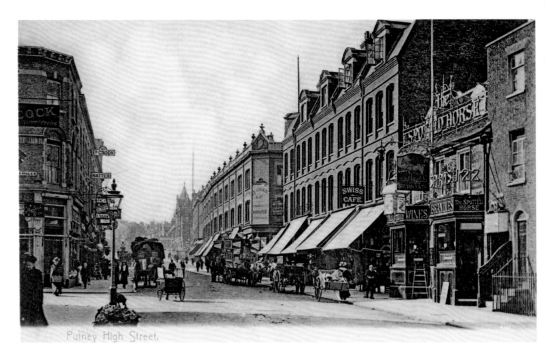

Putney High Street.

Putney High Street at Werter Road

The English writer, Arnold Bennett, was a frequent visitor and sometime resident of Putney. His 1908 novel *Buried Alive* was set there with its main protagonist, the painter and recluse Priam Farll, resident at 29 Werter Road. In the novel, Bennett describes the luxuriousness of Putney High Street, where there was 'not a necessary in the street. Even the bakers' shops were a mass of sultana and Berlin pancakes – no one slept there now because of the noise of motors'.

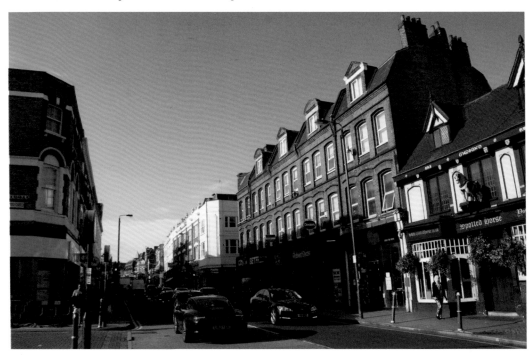

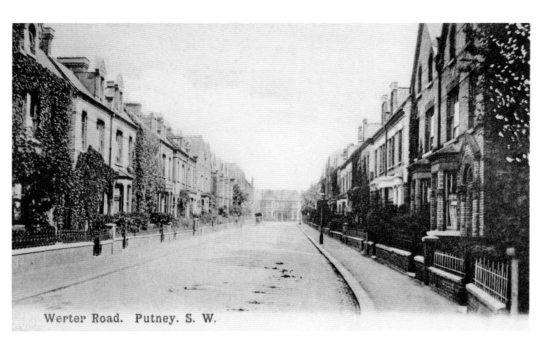

Werter Road. Putney. S. W.

Werter Road

Originally called Cambridge Road to complement Oxford Road, with which it adjoins, in honour of the University Boat Race. E. M. Forster, author of *Howards End*, *A Room with a View* and *A Passage to India*, lived at No. 22 Werter Road, marked in both images by the lamp post on the right.

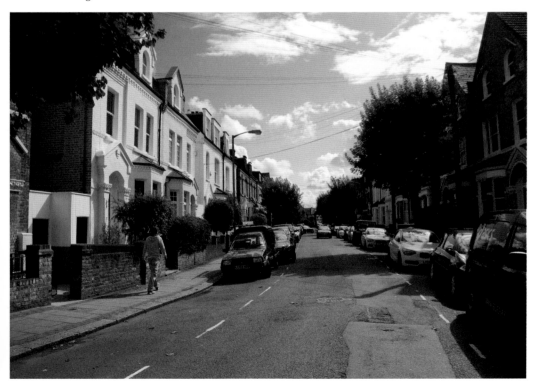

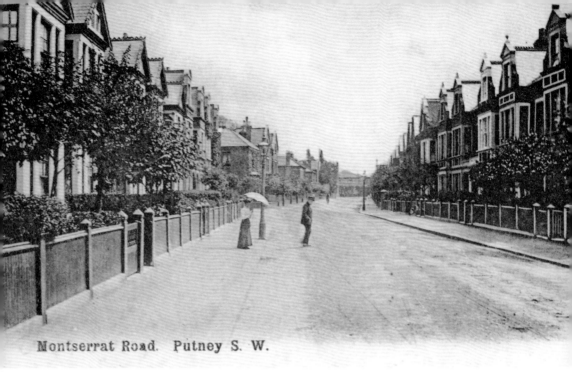

Montserrat Road. Putney S. W.

Montserrat Road
At the junction of Montserrat Road and Putney High Street, once stood the finest of all Putney's mansions. Elizabeth I is rumoured to have dined at Fairfax House, but the earliest parts date back only as far as the 1630s. The house was demolished in 1887.

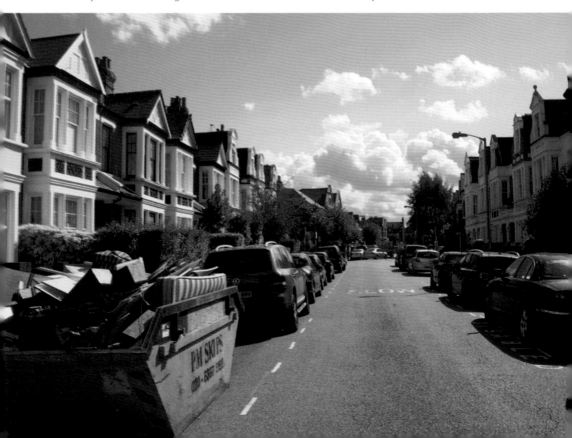

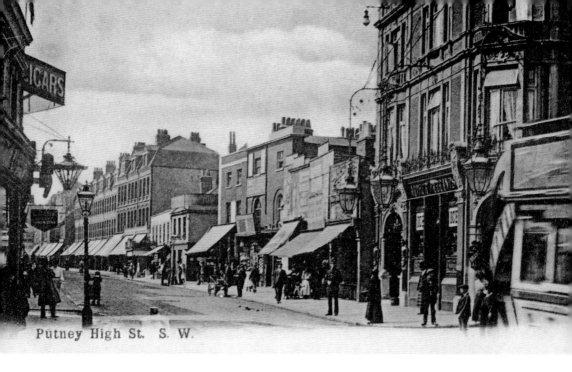

Putney High St. S. W.

Putney High Street at Lacy Road

The Coopers Arms public house once stood on the right, on the corner of Coopers Arms Lane, since renamed Lacy Road. Street lights can be seen at the side of the road, lit by gas. But the light provided was poor, and to read a newspaper you would have to be underneath it. Note the larger lights provided by some retailers.

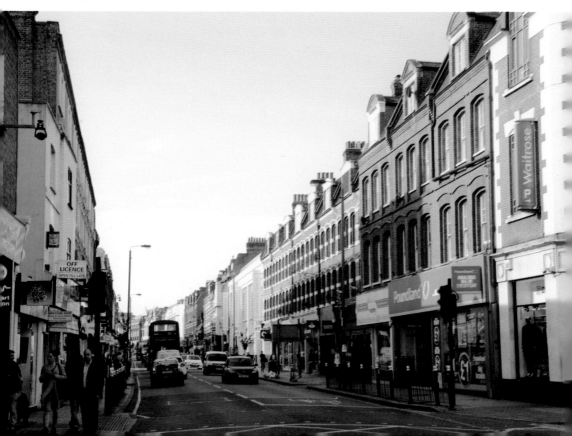

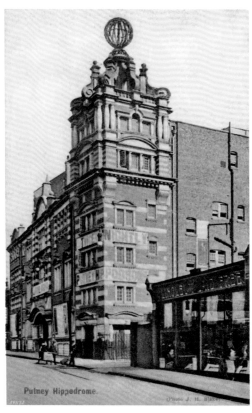

Putney Hippodrome.

The Hippodrome, Felsham Road
Standing on the west corner of Weimar Street and Felsham Road, the Hippodrome opened in 1906 and could accommodate an audience of more than 1,600 people. It became a cinema in 1924, eerily anticipating its later role after its closure in 1961 as a film set, the last of which was the 1973 Vincent Price horror film *Theatre of Blood*. The building was demolished in 1975 to make way for housing.

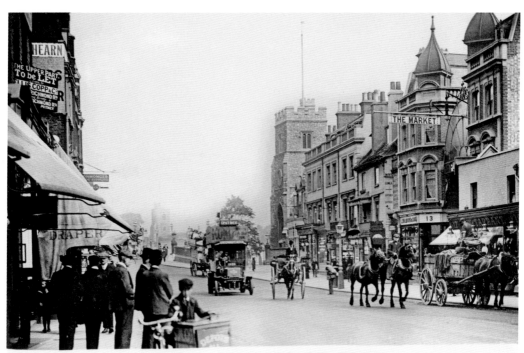

No. 2010. PUTNEY:—THE HIGH STREET

Putney Market, Putney High Street

The market was built in 1904 to improve the retail reputation of Putney. However, it was not a success and closed in the early 1920s, before making way for the Regal cinema in 1937.

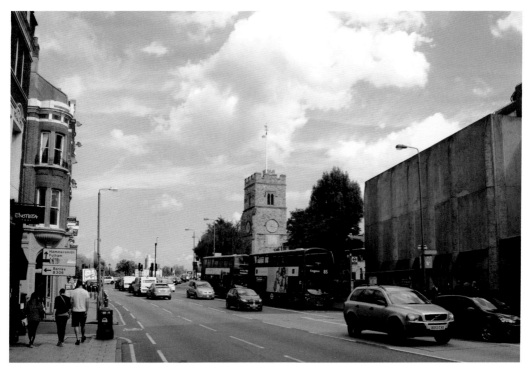

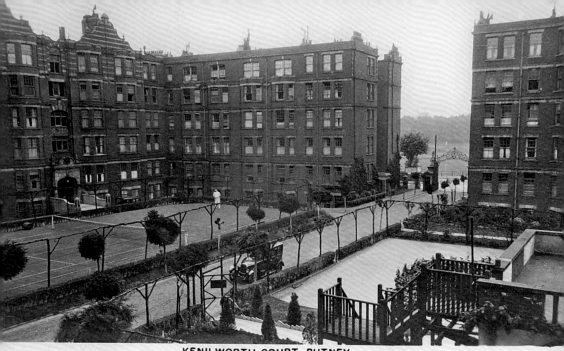

Kenilworth Court, Lower Richmond Road
The terrace of fine early nineteenth-century houses that once occupied this stretch of Lower Richmond Road was replaced by the last of the Kenilworth Court's eight blocks of flats in 1905. The central garden remains but the tennis court has gone. The poet Gavin Ewart, who wrote about life in Putney lived here, as did Baron Jenkins of Putney, Minister for the Arts and Putney MP, 1964–79.

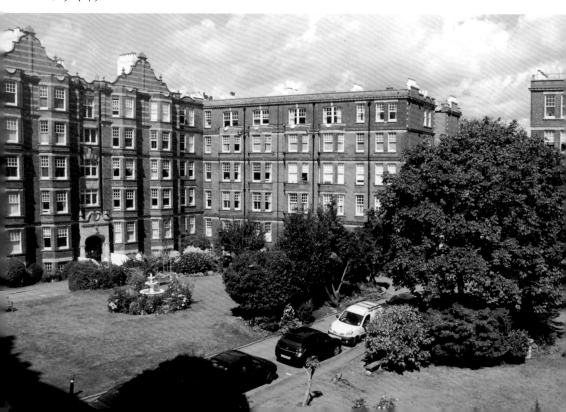

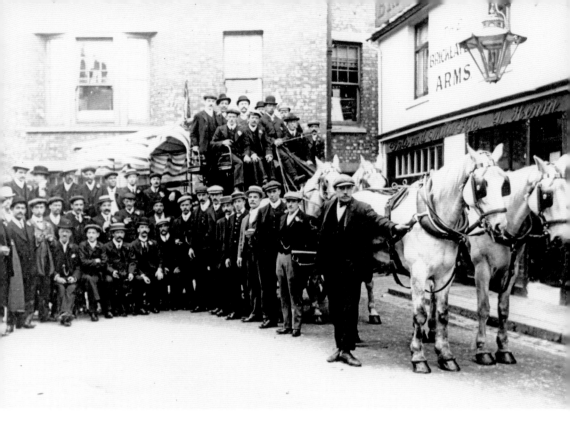

The Bricklayer's Arms, Waterman Street
The original building was built in 1826. In the late 1800s, as Putney went through an extensive period of building, it became a public house and took its present-day name to attract the construction workers.

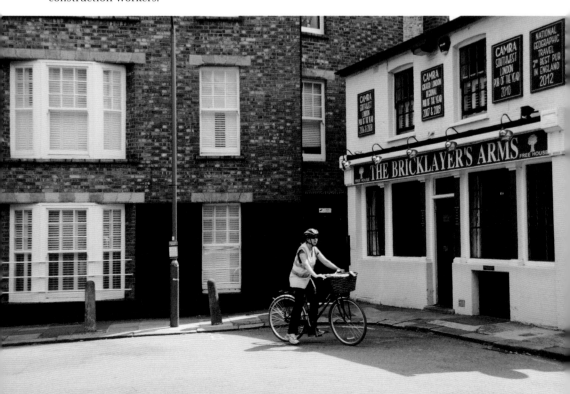

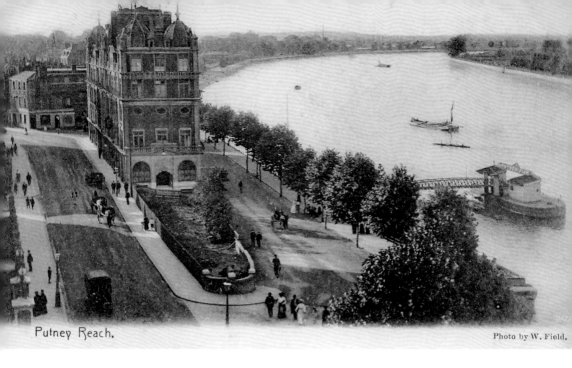

Putney Reach.

Photo by W. Field.

Putney Reach, Thames Embankment

With the Star & Garter towering in the background, Putney Pier reaches out over the Thames towards the start of the famous Oxford and Cambridge University Boat Race. Today, even ordinary commuters can be transported by boat by the River Bus service that operates from the pier.

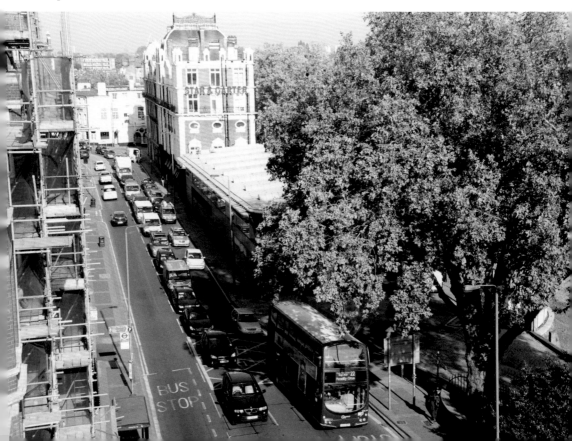

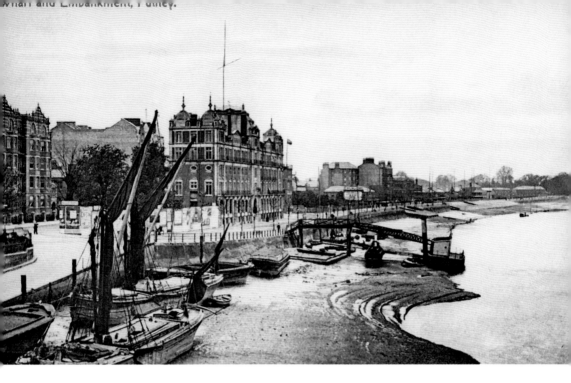

Putney Wharf, Thames Embankment

Old barges rest on the foreshore at Putney Wharf. Following the completion of the new Putney Bridge in 1886, the present embankment of stone was built westwards along the river as far as the Beverley Brook at Barn Elms, Barnes. Today, Putney Wharf increasingly associated with Putney Wharf Tower, the 1960s former ICL office block redeveloped into sixty-seven apartments, and a restaurant in 2003 on the St Mary's side of the bridge.

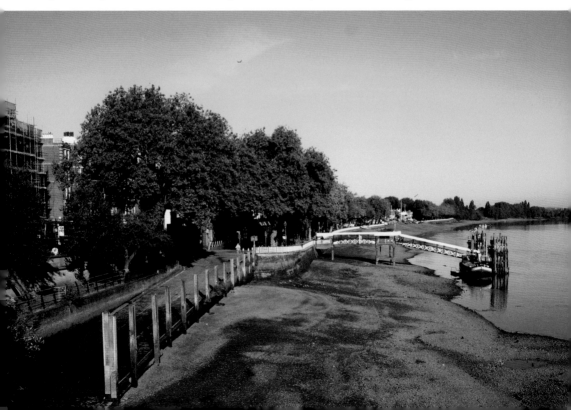

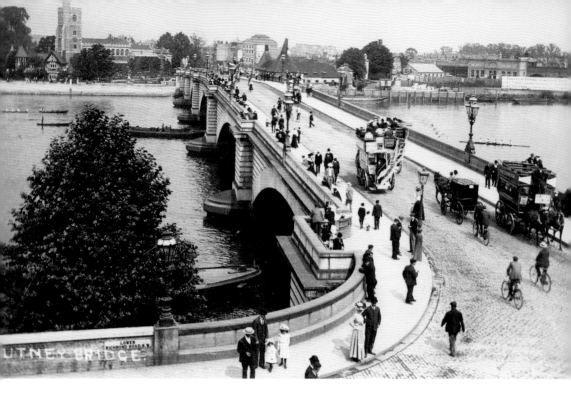

Putney Bridge

The Metropolitan Board of Works purchased the old bridge in 1879 and discontinued the tolls the following year. A new bridge of stone and Cornish granite, designed by Sir Joseph Bazalgette, was started in 1882 and opened by the future King Edward VII on 29 May 1886. The bridge was widened in 1933 and closed for essential repairs over the summer of 2014. It is reputed to be the only bridge in Britain to have a church at both ends.

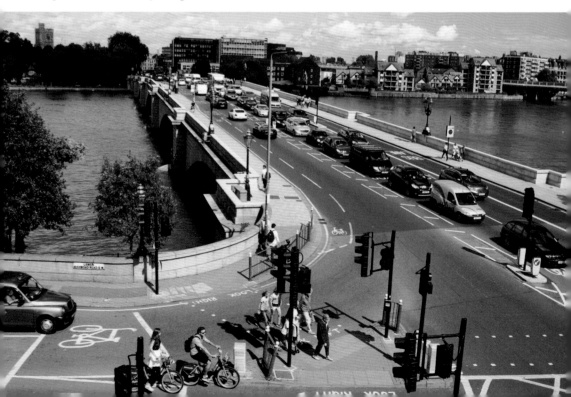

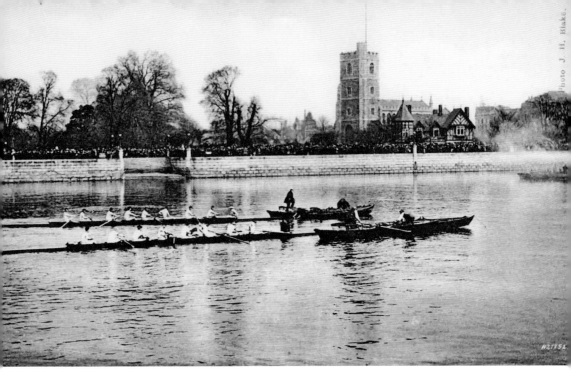

University Boat Race, River Thames
First contested in 1829 at Henley-on-Thames, the University Boat Race moved to Putney in 1845 and has been an annual event since 1856. The race starts from two stake boats moored in the river just west of the bridge so that the competitors' bows are in line with the University Stone set into the towpath on Putney Embankment, a few metres below Putney Bridge. An equivalent stone in the bank next to The Ship pub in Mortlake 4.2 miles upriver marks the finish of the race.

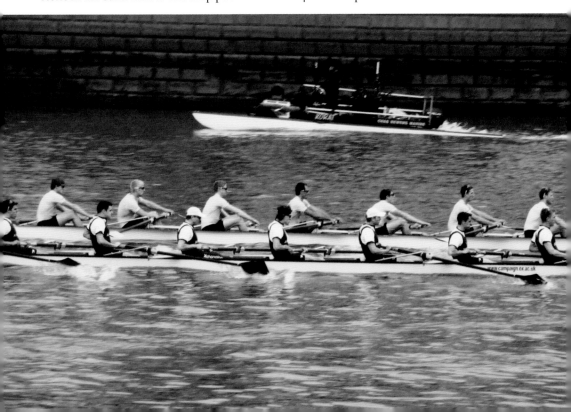

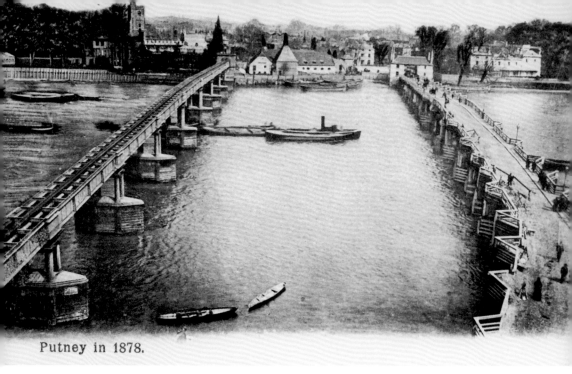

Putney in 1878.

Old Aqueduct and Bridge

This view taken in the early 1880s from the tower of St Mary's church shows the old wooden structure completed in 1729, only the second bridge (after London Bridge) to be built across the Thames in London. Although unpopular, tolls continued to be collected from those crossing the bridge for 150 years until 1879. The aqueduct on the left, originally owned by the Chelsea Waterworks Co. and carrying potable water from the reservoirs on Putney Heath across the river, marks the course of the new bridge, into which it was incorporated.

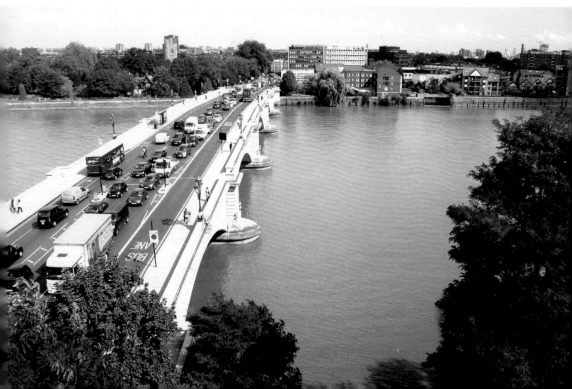

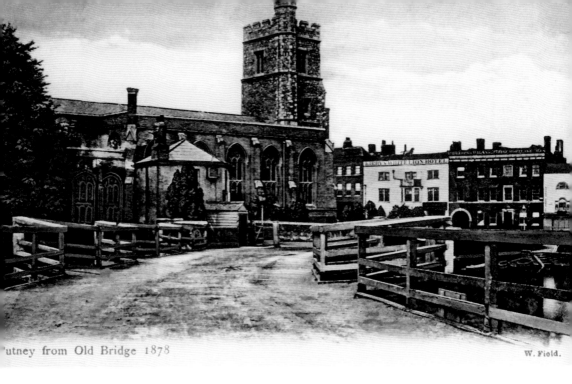

Putney from Old Bridge 1878

W. Field.

St Mary's Church

The church stands on a site of Christian worship from at least the thirteenth century. The tower of St Mary's is generally believed to date from *c.* 1500, and Bishop West Chapel dates back to the time of Henry VIII in the early sixteenth century. The rest of the church was rebuilt in 1836. In 1647, during the English Civil War, the church was the site of the Putney debates on the English form of government. An arson attack gutted much of the church in 1973 and rebuilding was not completed for nine years, after which the church was rehallowed on 6 February 1982. In 2005, a new extension, the Brewer Building, was added at a cost of £1.7 million.

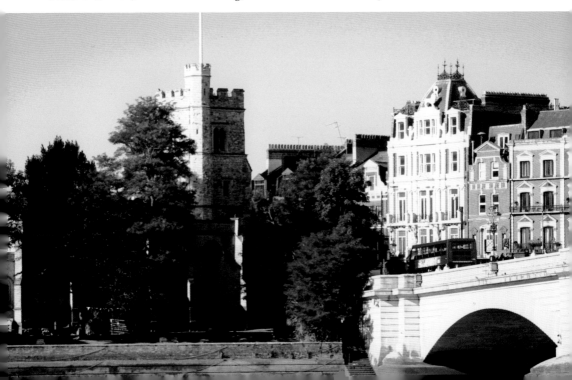

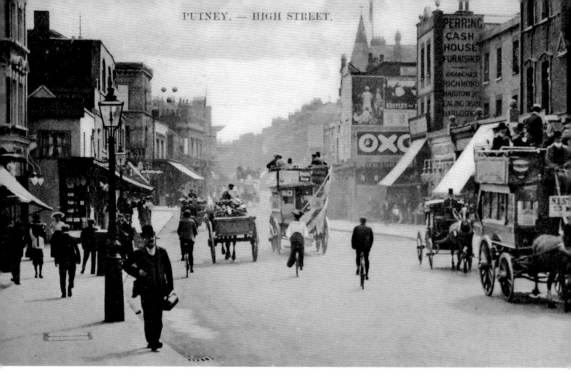

Putney High Street (Facing South)

This is the view taken in around 1900 from near St Mary's church looking southwards. On the left-hand side just beyond the two carts can be seen the start of Putney Bridge Road. Notice the open-topped horse-drawn omnibuses and behind the one on the right is 'Clarence' carriage (probably private-owned or used as a hackney carriage, that is, taxi).

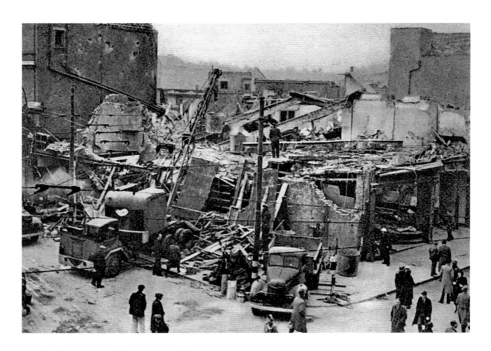

Bombed Dance Hall, Putney High Street
During the Second World War, a German bomb hit the Black and White Milk Bar and the Cinderella Dance Club at No. 35 Putney High Street, killing eighty-one people and injuring 248 others. The message on the back of the photograph reads: 'Nov 7 1943. Demolition crews at work on the Dance Hall and Milk Bar in Putney High Street after a lightning German attack by a lone bomber'.

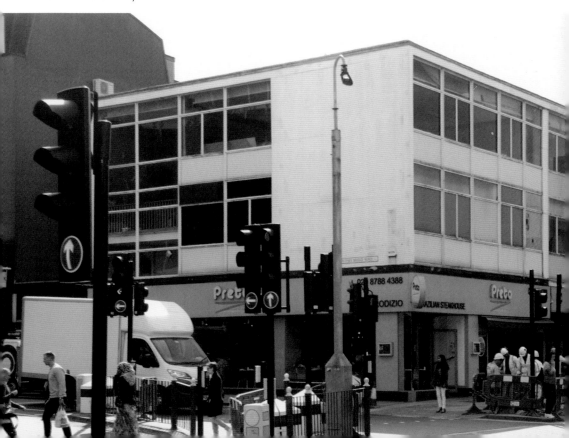

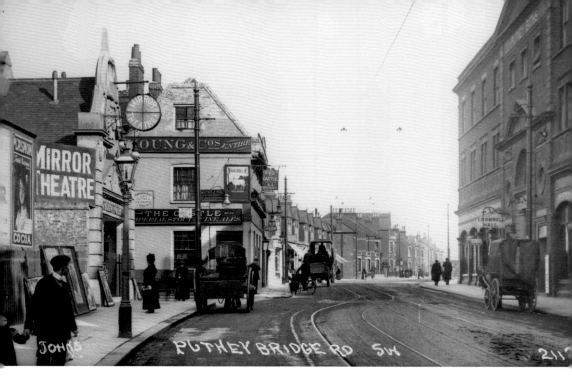

Putney Bridge Road near Putney High Street

The Mirror Theatre was Putney's first cinema. The building was last used by Deans Blinds as a workshop and demolished in around 1972. Note the single track for trams passing the Castle public house: shopkeepers had the right to park their carts on the road outside their premises, so the tram tracks had to be some distance from the kerb.

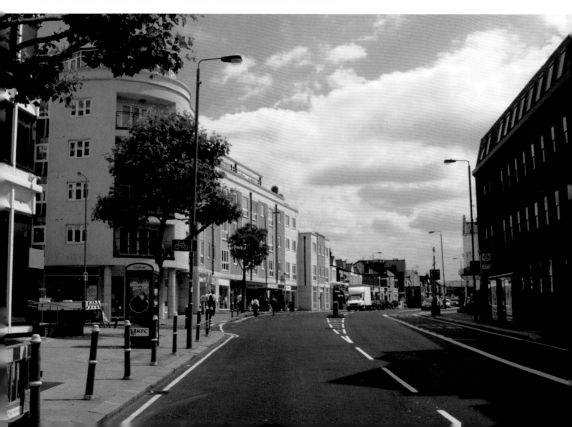

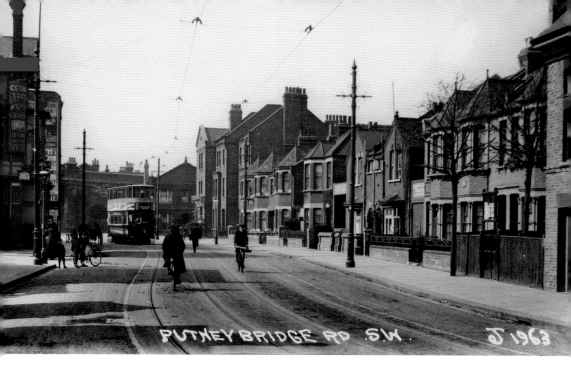

Putney Bridge Road at Wadham Road
Putney Bridge Road was formerly called Love Lane and Wandsworth Lane. Wadham Road was called College Street up to 1938. As in this picture, cyclists rode between the tram tracks where the road was flatter, but mainly because it avoided the need to cross the tracks and risk catching a wheel in the rails when overtaking parked vehicles.

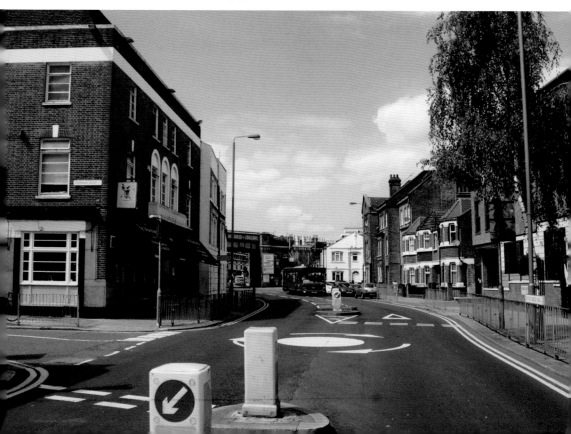

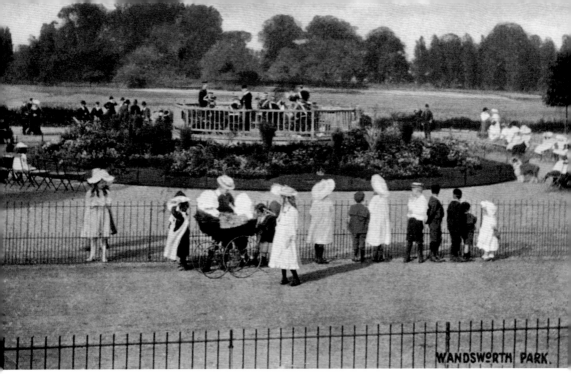

Bandstand, Wandsworth Park

In 1897, market garden land was offered to the Wandsworth District Board. A small part of it was used to widen Putney Bridge Road and the rest to convert the then natural riverbank into a promenade. The design took account of cost, a shortage of gardeners and general interest in organised sport. A few improvements have taken place since then but, in essence, the layout has little changed. It was granted Grade II listing in 1987.

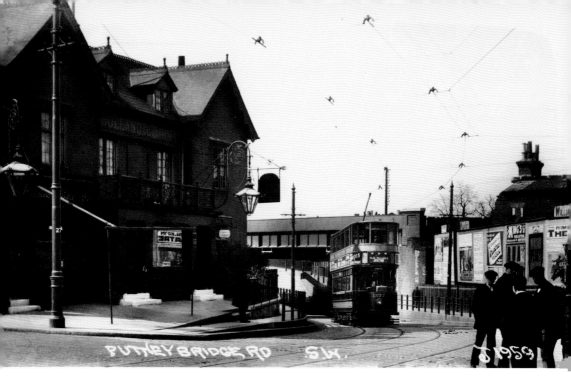

Queen Adelaide, Putney Bridge Road

There has been a pub on this site at least from the eighteenth century. The future Queen Adelaide did not come to prominence until 1818 when she married Prince William, having met him for the first time only a few days before. He became King William IV in 1830. The queen consort was loved by the people for her charitable work and modesty.

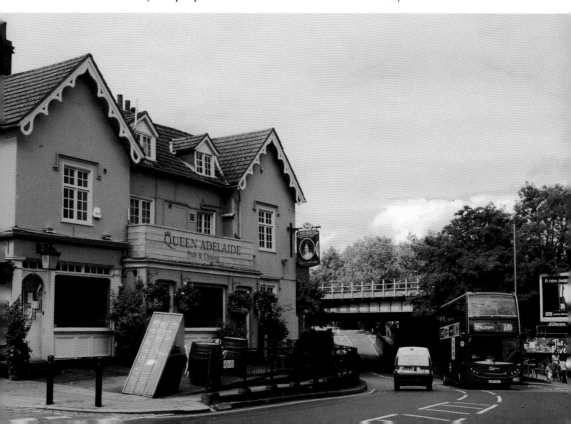

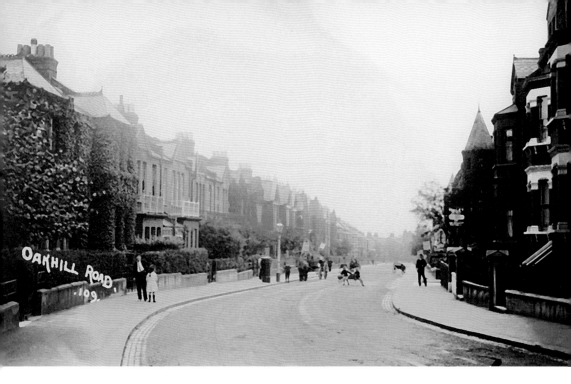

Oakhill Road

East Putney largely comprised small farms and fields, with a few large houses close to the main roads and the occasional village or hamlet. The nature of the area began to change dramatically in the latter half of the 1800s when the roads were developed and housing began to be built. The houses in Oakhill Road demonstrate variety of styles largely from the end of the nineteenth century.

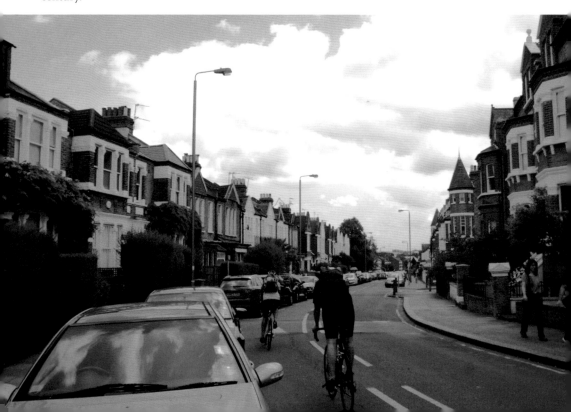

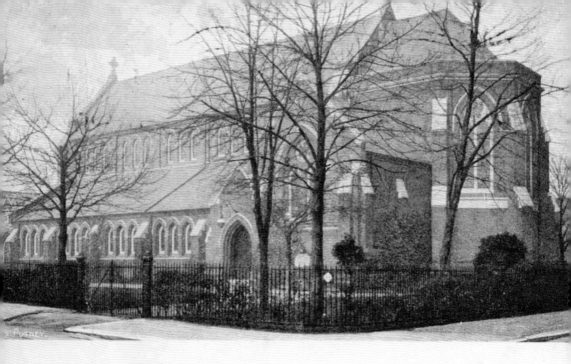

ephen's Church, East Putney.

St Stephen's Church, Manfred Road
An iron church opened on this site in 1877 and was replaced with the one in the top picture in 1882. It served its parishioners well for nearly a hundred years. The parish then decided that it should be demolished in 1979 to use the land for a smaller St Stephen's church nearby and a block of flats.

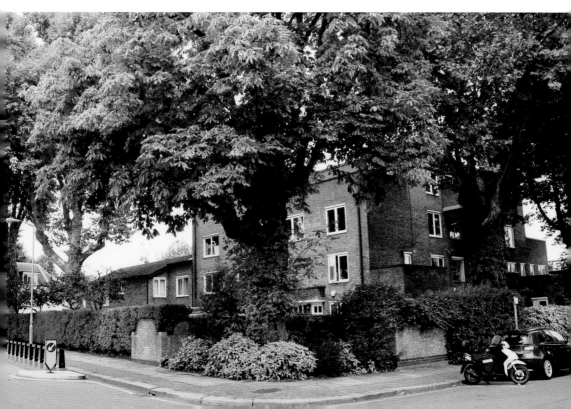

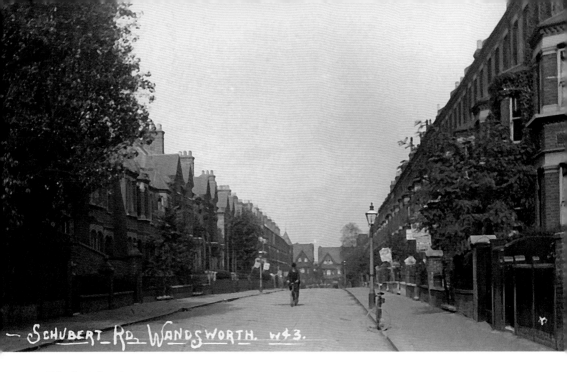

— SCHUBERT RD. WANDSWORTH. W+3.

Schubert Road

Named for the Austrian composer, who died at the young age of thirty-one, the first house numbers were assigned in 1887. Today the road is remembered for another musician of an entirely different age and genre, Marc Bolan, the singer with the 1970s glam rock band T. Rex. Bolan lived at No. 7a Schubert Road, Putney, and died in a car crash in Queens Ride, Barnes, on the border of Putney at the even younger age of twenty-nine.

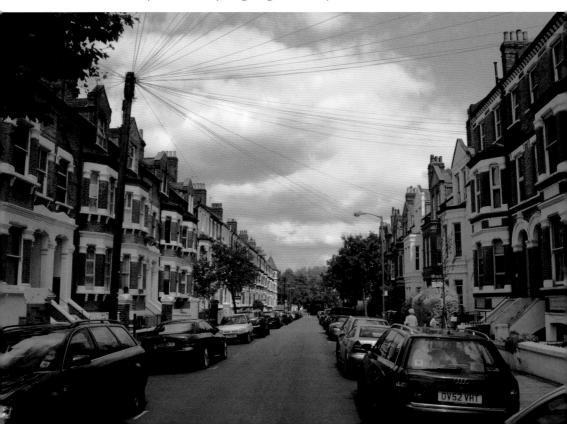

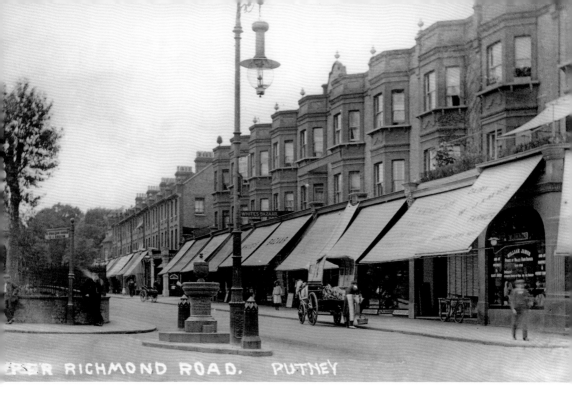

ER RICHMOND ROAD. PUTNEY

Upper Richmond Road at West Hill

This row of the shops, which was close to the junction of Upper Richmond Road with West Hill, was typical of those that neighbouring households would visit each day to buy essentials, such as milk (from Alderney cows) and bread, and where wholesalers could safely tie up their horses and carts and pass some time smoking a pipe and watching life go by (much more slowly than today).

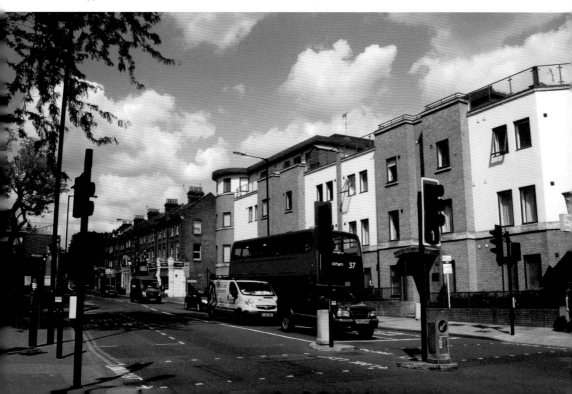

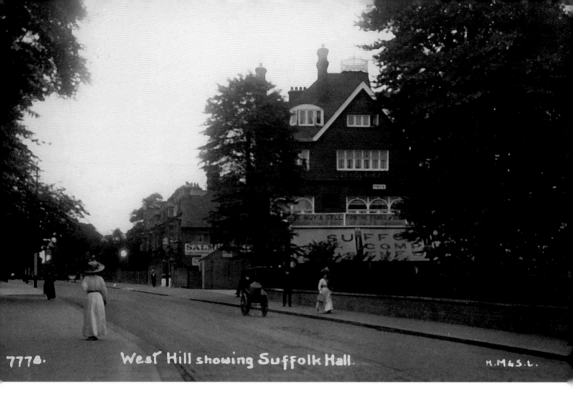

7778. West Hill showing Suffolk Hall. M.M&S.L.

Suffolk Hall, West Hill
Suffolk Hall was one of the halls/hostels used by the Young Women's Christian Association (YWCA). The movement began in England in 1855 during the Industrial Revolution. Initially it sought to protect women morally and socially, but by 1910, it began to concentrate on educating working women about social issues.

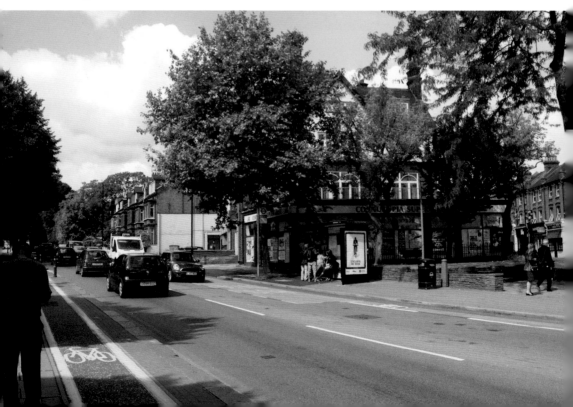

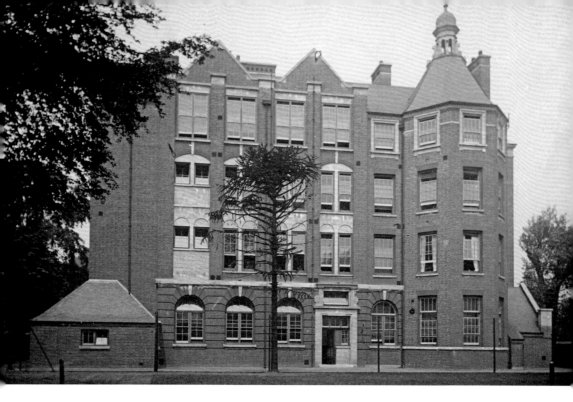

Mayfield School, West Hill

Mayfield opened as a girls' secondary school in Mayfield House, West Hill, in 1907. Two years later a four-storeyed building was built nearby and the house was demolished. In 1955, it was the first grammar school to become a comprehensive school and was the largest school for girls in the country. The school closed in 1986 when it merged with Garratt Green School (now Burntwood) as a result of falling numbers.

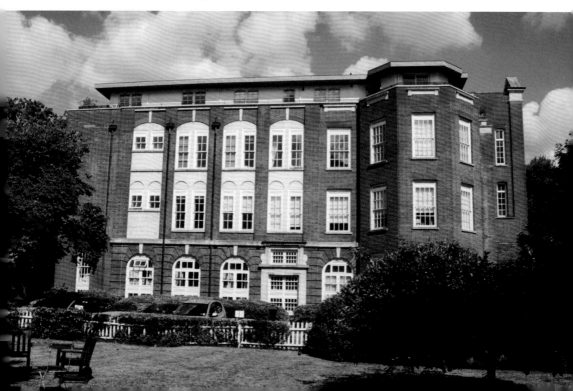

Rusholme Road
Between 1895 and 1906, a new scheme of
houses known as the Clock House estate
was built straddling the old parish boundary
between Wandsworth and Putney. A
conservation area, today it includes Dromore,
Holmbush and Rusholme Roads, Lytton
Grove, parts of Putney Heath Lane and the
north-west side of West Road. The older
photograph dates from around 1915 but one
hundred years on, in spite of some changes,
many of the original features have been
sympathetically treated and maintained.

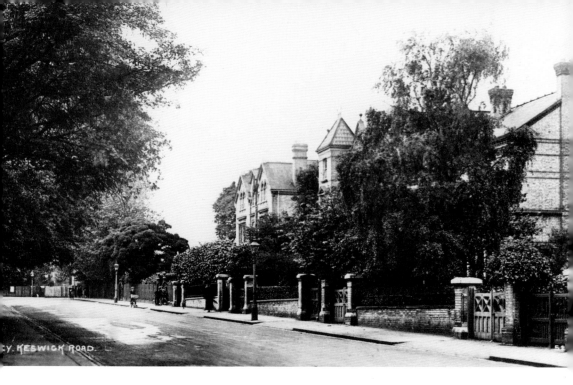

CY. KESWICK ROAD.

Keswick Road
Keswick Road was defined in 1865 and large detached and semi-detached houses were built over the following twenty years. By 1900, the road was well developed. The northern part of the road has Victorian buildings infilled with twentieth-century houses often due to bombing during the Second World War. Many of the houses in the southern part of the road are locally listed especially due to the influence of arts and crafts and French Renaissance styles.

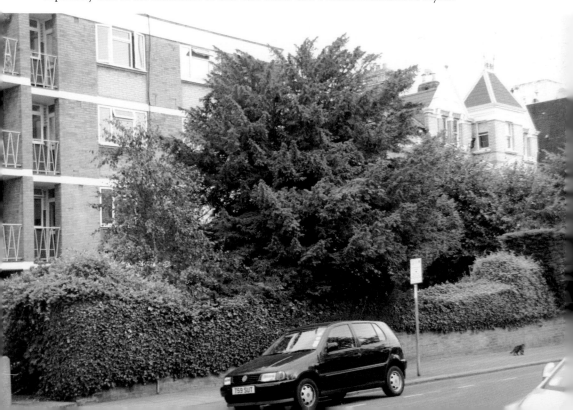

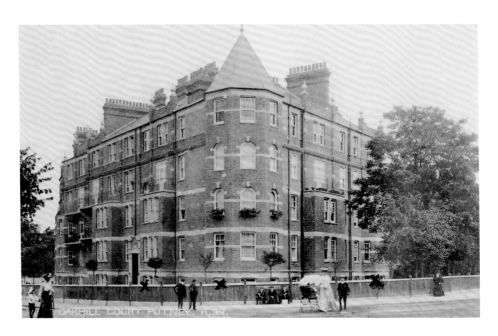

Oakhill Court

The message on the back of postcard was from the maid at No. 23 Oakhill Court in 1906: 'We have moved to Putney but not for long, we are in the bottom flat on this card, they are very large flats but I would sooner live in a house ... they are trying to sell their house but it is a job to, so my Misses told me that I should have to leave, if she cannot keep me up, to get a cheaper maid. I shall no (sic) in a week. I do hope I shall be able to stop, she does not want me to go. Putney is a very nice place'.

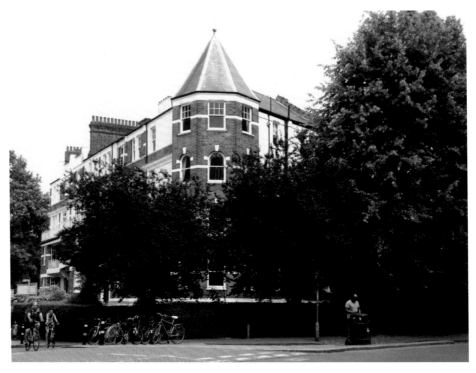

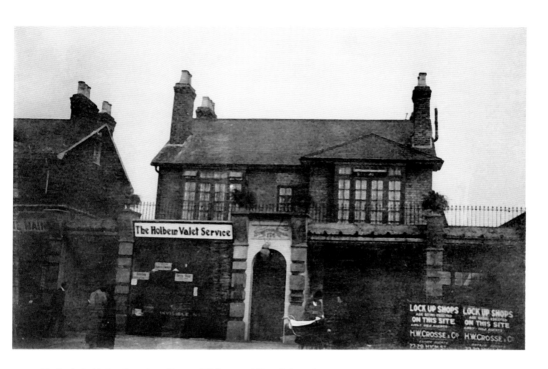

Holbein's Valet Service, Upper Richmond Road (East)

In the 1900s, the Upper Richmond Road between East Putney station and Putney Hill was full of small shops such as shown here with a single storey above – probably as the home of the shopkeeper and his family. Today, the same stretch of road is lined with shops and other businesses, but now the apartment blocks above are several storeys high.

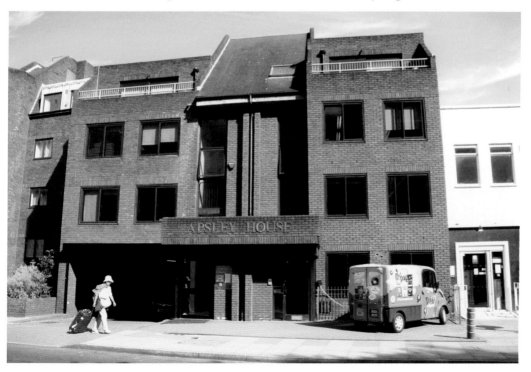

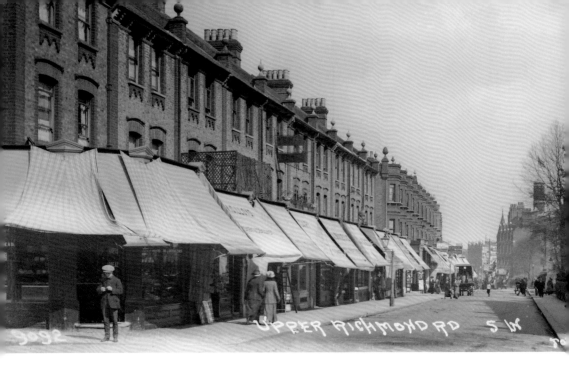

Shopping Parade, Upper Richmond Road
A typical row of shops providing all the items and services that were needed for the family. The use of the roller blinds was normal, partly to provide cover if it rained. But, more importantly, they provided protection from the sun though not for the passers-by. In the sun, items in the window would suffer; foodstuffs would go off and clothing and other materials would fade.

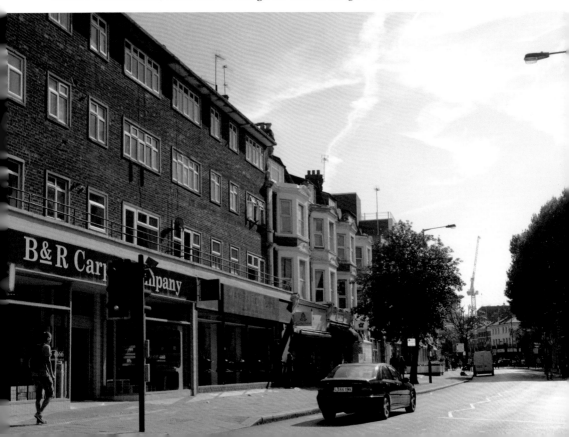

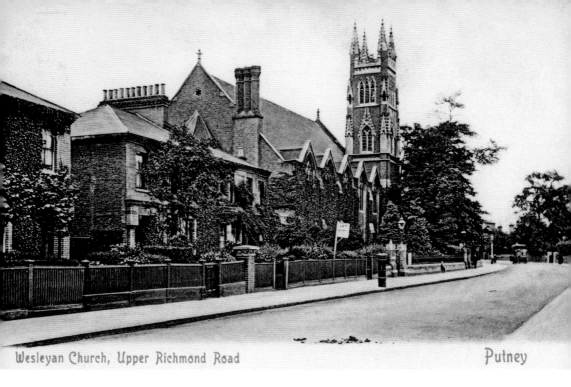

Wesleyan Church, Upper Richmond Road

Putney

Wesleyan Church, Upper Richmond Road
Putney Methodists originally used a former laundry for services but by 1865 needed a larger space. They built a school chapel in 1870 but it was compulsorily purchased and by 1882 the Methodists had replaced it with this early English Gothic 1,000-seater church built for less than £6,000. Although the title Wesleyan is not inappropriate, it is now referred to as the Methodist church.

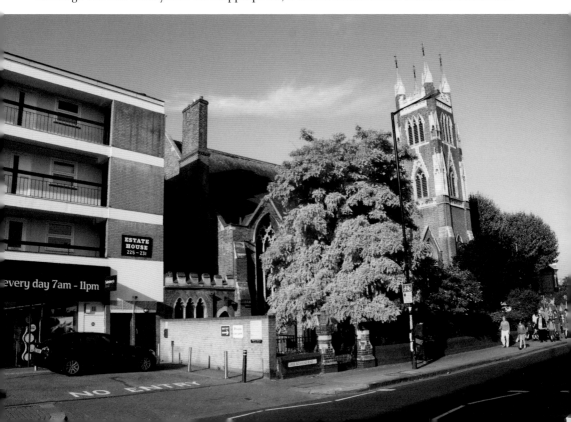

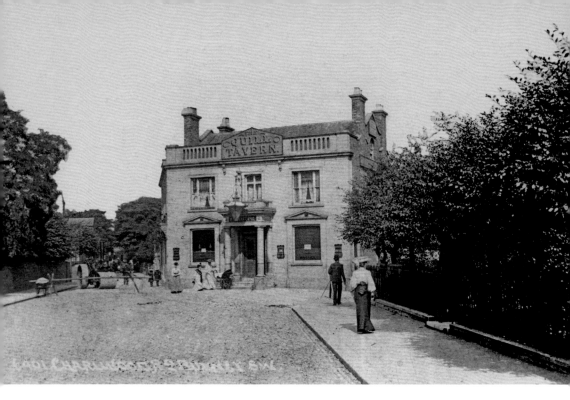

Quill Tavern, Charlwood Road
No. 22 Charlwood Road was the site of the Quill Tavern (named for the adjoining Quill Lane) from the mid-1800s. It was rebuilt in the 1960s before being demolished to make way for an apartment block, considered by some as more in keeping with the surroundings.

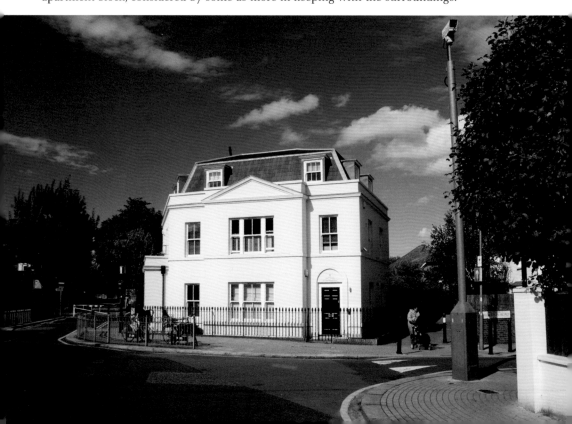

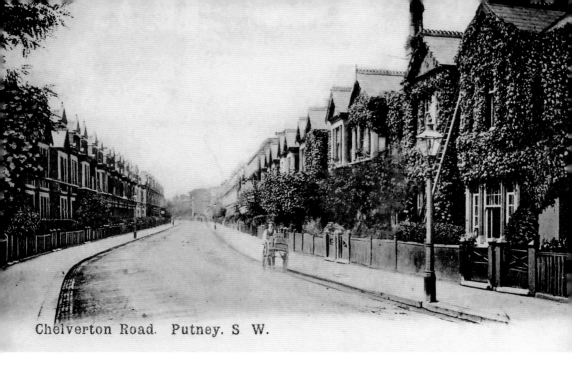

Chelverton Road. Putney. S. W.

Chelverton Road (West)

Chelverton Road is illustrative of the way many streets between the Upper and Lower Richmond Roads change character over a short distance. This end is lined with the homes of the reasonably affluent which would have had at least one servant. In contrast, at the far end of the road where it joins Putney High Street were the stables for the horses that pulled the omnibuses for the London General Omnibus Company, on the site of which stands the present bus garage.

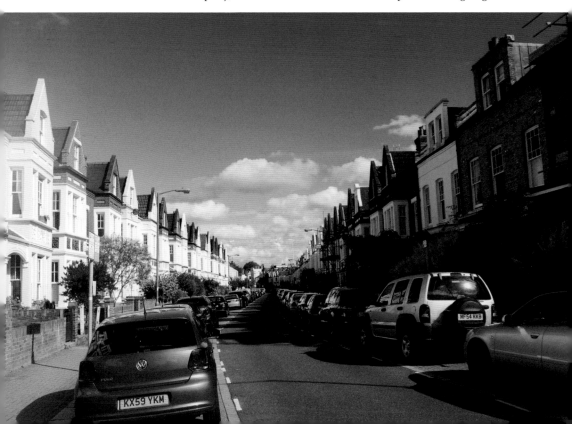

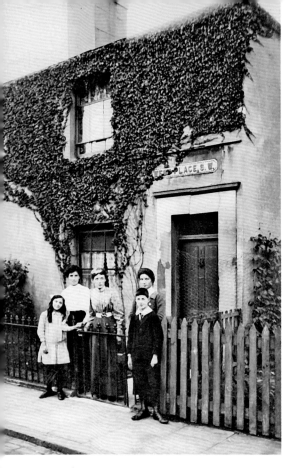

West Place
The girl on the left was born in 1903, and this photo was taken in around 1912. In 1937, the name of the road was changed to Glegg Place. The original cottages have since been demolished and replaced with a block of flats on the opposite side to the Jolly Gardeners public house.

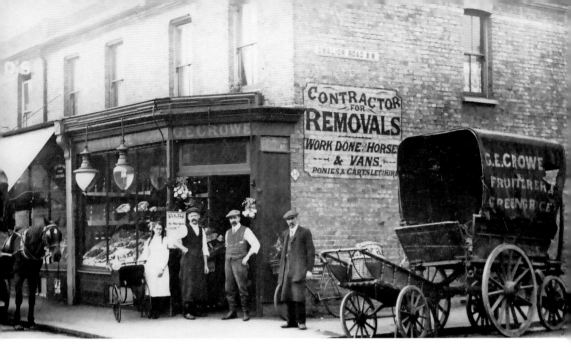

Crowe's Greengrocers, Gwailor Road

Crowe's greengrocer stood at the corner of Gwalior and Lacy Roads in around 1910. Note the different types of transportation of a hand barrow or a horse-drawn cart, and the baby in a well-sprung perambulator to the left of the group. The contractor might own and stable his horses or hire them from a jobmaster (equivalent to modern-day car hire).

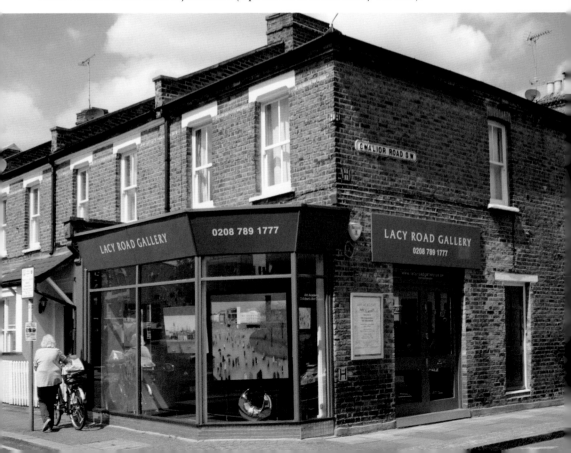

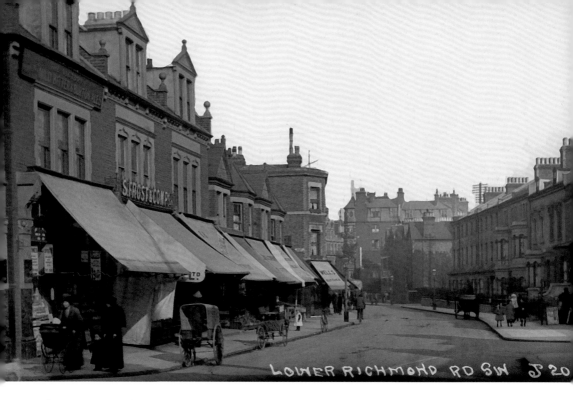

LOWER RICHMOND RD SW J 20

Shops, Lower Richmond Road

The parade of shops that used to line the northern side of Lower Richmond Road, previously called Windsor Street. Shops with south-facing windows normally needed blinds (note that the shop on the other side of the road is not using blinds). From the evidence in the middle of the road, the traffic then was still largely horse-drawn!

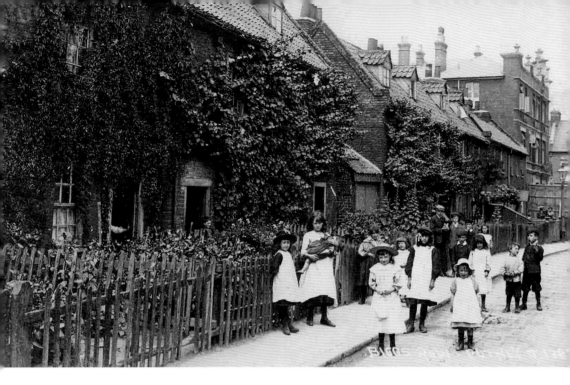

Bigg's Row

The children are dressed in their best clothes, so the photograph may well have been taken on a Sunday. One of the older girls is looking after her baby brother or sister. The postcard with this picture was sent from Putney to Fulham with the message that the writer would visit the recipient that same afternoon, confident that the card would arrive a couple of hours after being posted!

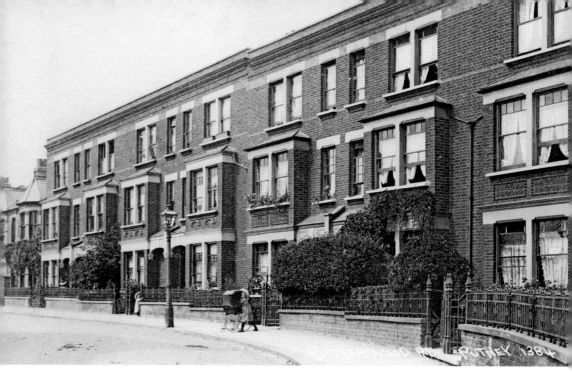

Rotherwood Road

An attractive block of properties when they were first built, and they remain largely unchanged today. Some of the replacement windows jar and the front garden boundaries are varied. The railings in front were presumably removed during the 'Scrap Drives' of the 1940s with the intention of melting them down for the war effort.

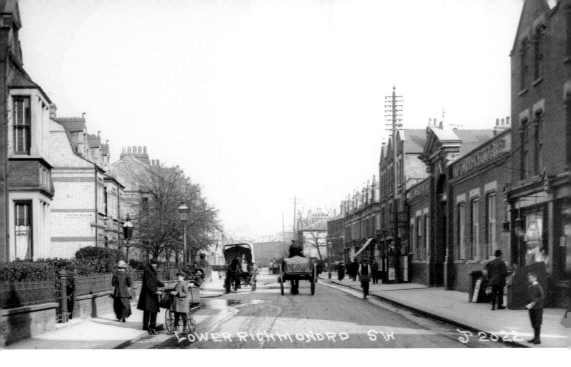

Gated Entrance, Lower Richmond Road

A busy view along the main road at the junction, with Festing Road on the left. The original single-storeyed building on the right has now been replaced with a modern three-storeyed building, but it retains the entrance to the then Cunard Motor and Carriage Co. Ltd, founded in 1911 and before continued in various guises until the 1960s.

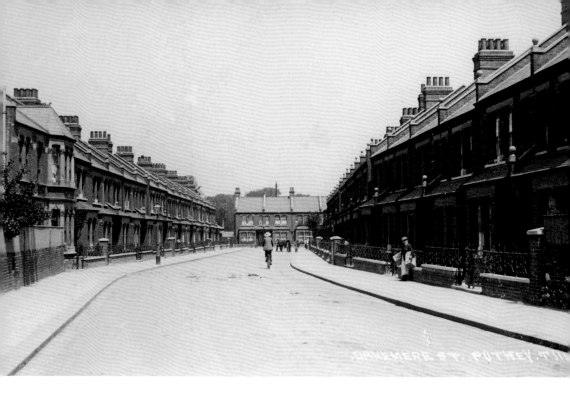

Danemere Street

A peaceful summer's day in the early 1900s with a lone cyclist, a tradesman's cart in the distance and the delivery boy taking a rest while he is carrying empty delivery boxes. It is striking how much wider the roads appear when there are no parked vehicles.

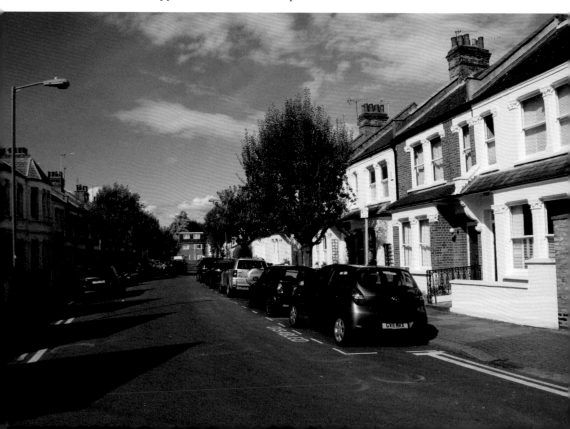

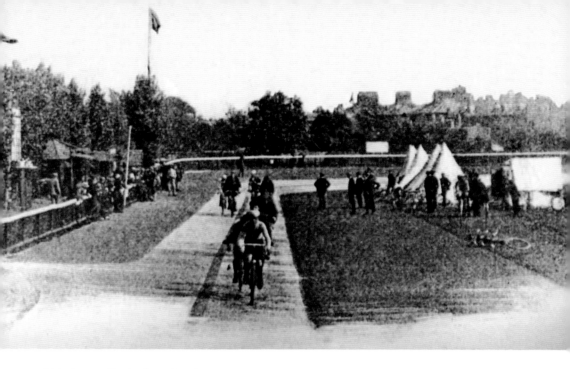

Velodrome, Erpingham Road

The Putney velodrome was the first concrete cycling track in the country. It was built on the land surrounded by the four roads: Erpingham, Hotham Rossdale and Clarendon Drive, where the entrance stood. The track was also used for athletics, especially for long-distance walking. It did not survive long, however: improved transport links increased demand for housing in the area, which in turn led to the closure of the velodrome in 1907.

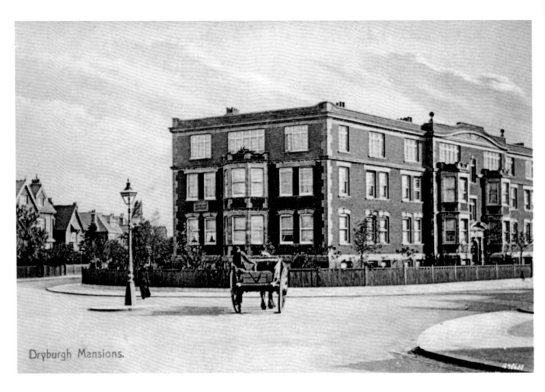

Dryburgh Mansions.

Dryburgh Mansions, Erpingham Road
The building is believed to date from around 1900 and is listed within the local conservation area. Four storeys with a parapet, the building is visually distinguishable from its two-storeyed neighbours and dominates the junction of five roads below it.

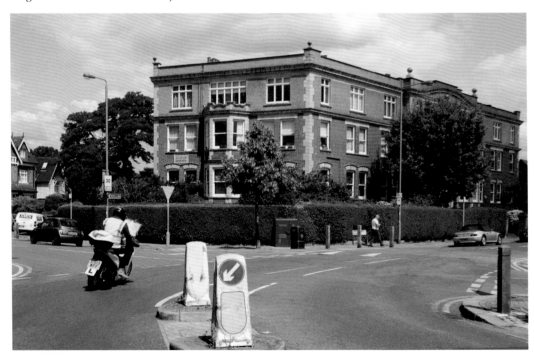

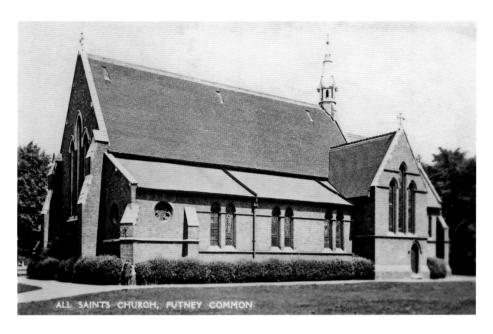

ALL SAINTS CHURCH, PUTNEY COMMON

All Saints Church, Putney Lower Common

Commissioned to serve the poor of Putney with their own church and built on land donated by Earl Spencer, the foundation stone was laid by HRH Princess Christian of Schleswig-Holstein on 25 April 1874. Designed by William Morris and Edward Burne-Jones, it is a fine example of a late Victorian arts and crafts church, with decoratively painted ceilings and beautiful stained glass windows. In January 1993, it suffered an arson attack, like St Mary's twenty years earlier, but on this occasion, the police caught the culprit moments after he had ignited oil in the boiler room. The church nevertheless required a £1 million renovation programme, including a new roof.

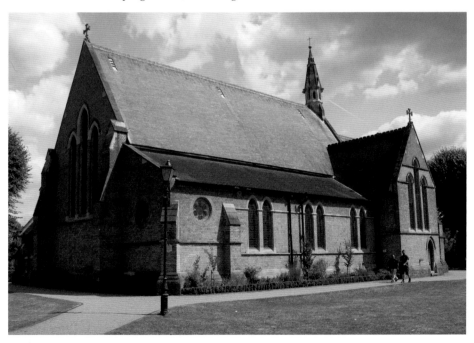

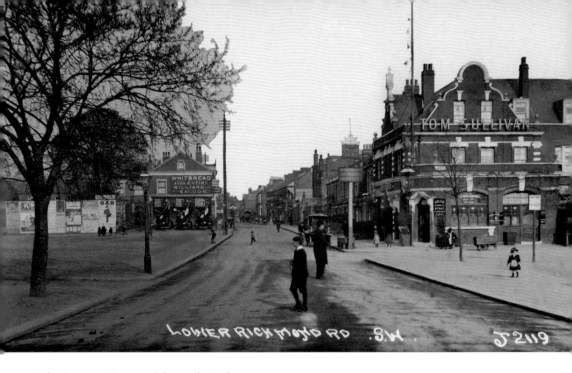

The Spencer, Lower Richmond Road

One of several pubs in and around Putney named after the former Lords of the Manor of Wimbledon, the Earls Spencer, who controlled common land in south west London. After unsuccessfully attempting to enclose some of the land in 1864, the 5th Earl conveyed his interest in Putney and Wimbledon Commons to a body of Conservators under the Wimbledon and Putney Commons Act in 1871. The Spencer family continued to retain the title of Lord of the Manor until 1996 when the current Earl, brother of Diana, Princess of Wales, sold it to an anonymous Brazilian for £171,000, a record at the time for sales of this kind.

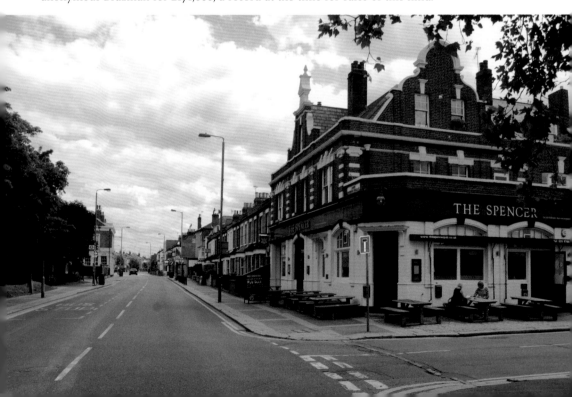

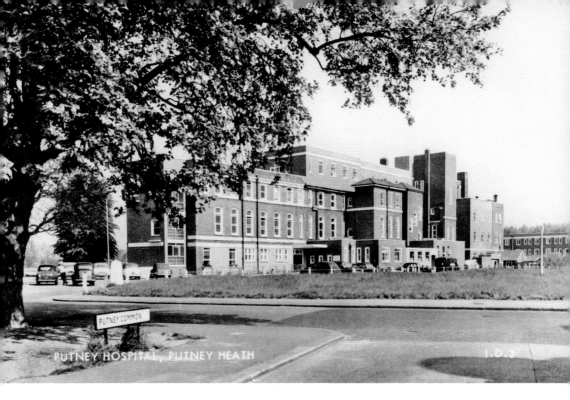

PUTNEY COMMON

PUTNEY HOSPITAL, PUTNEY HEATH

I.D.3

Hospital, Putney Lower Common

The hospital on Putney Common was built in 1912 on the site of Elm Lodge and West Lodge. It closed in 1998 and was bought by Wandsworth Borough Council to become a new primary school with twenty-four flats at the northern end of the site. A dispute over the amount paid for the land continues at present to divide the Board of the Wimbledon and Putney Commons Conservators.

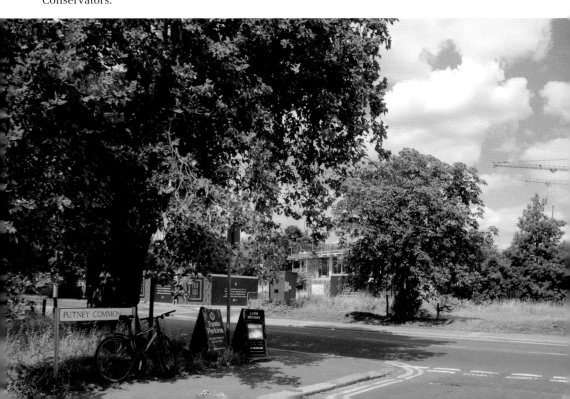

PUTNEY COMMON

Travis Perkins

LATIN ODYSSEY

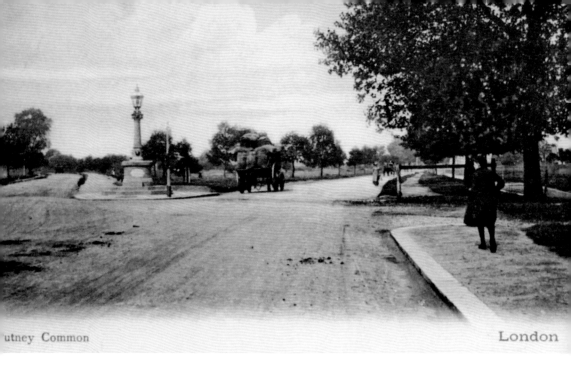

Putney Lower Common
Putney Lower Common is defined as the area between Lower Common South to Beverley Brook to the north with the Putney Cemetery to the west and Commonside to the east. This view shows the continuation to the west from the Lower Richmond Road.

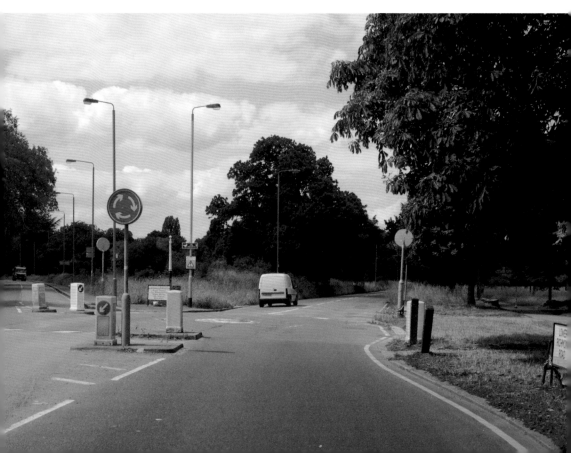

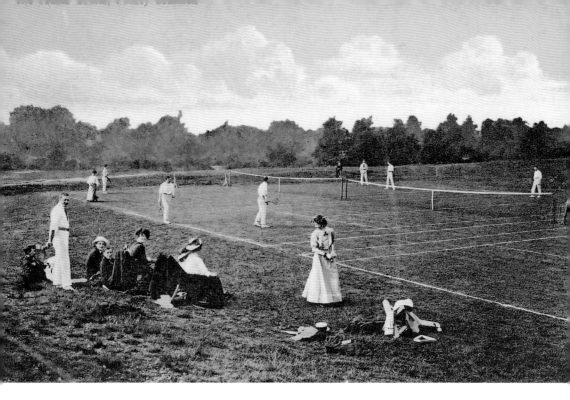

Tennis Courts, Putney Lower Common
The earlier picture dates from around 1905. These tennis courts were on the ground between All Saints church and Erpingham Road. Previously, in the late nineteenth century, the ground was occupied by a farm.

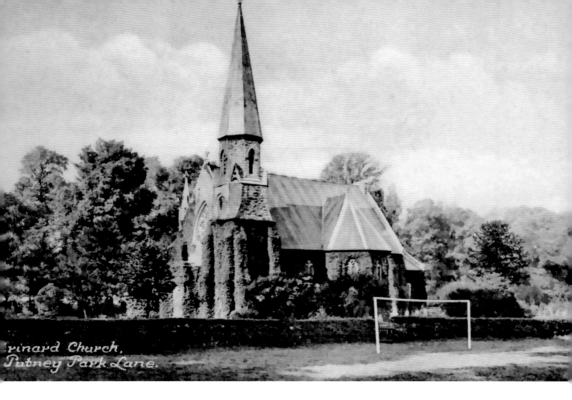

rinard Church,
Putney Park Lane.

Granard Church, Putney Park Lane

Granard church was on the eastern side of Putney Park Road facing Crestway on the Dover House estate. It was originally the chapel of the adjacent Granard House. Putney was expanding and so was the size of the congregation. The chapel was donated by its owner to the Putney Church Council in 1912 to provide another church. It is now the site of Granard Primary School.

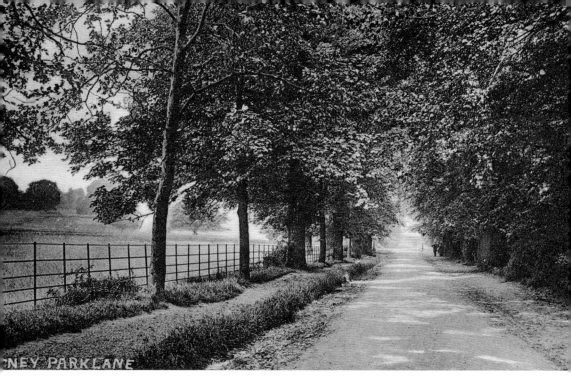

NEY PARK LANE

Putney Park Lane

John Rocque's map of 1740 shows Putney Park Lane originally as an avenue of trees running through the grounds of Putney Park House. In this view it was still a country lane *c.* 1905, fifteen years before the development of the Dover House Estate. The estate occupies land which rises gently southwards from the Upper Richmond Road.

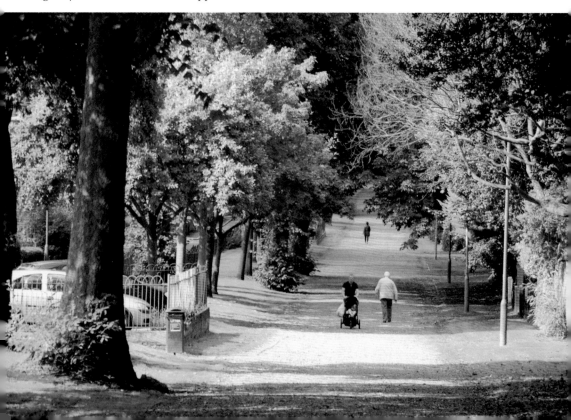

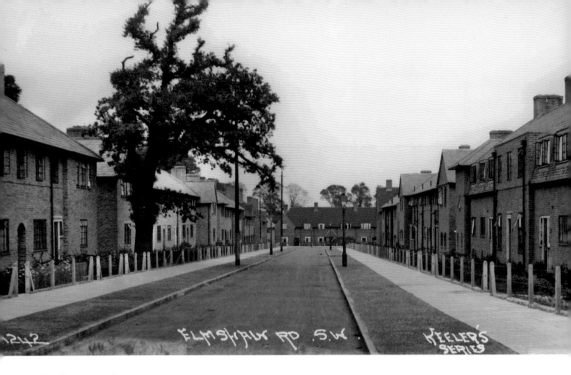

Elmshaw Road

In 1919, the London County Council (LCC) purchased Dover House and Putney Park House and their estates. There was a great housing shortage after the First World War and the LCC decided to build in the suburbs. The estate was one of the first cottage estates and there is considerable variety in the appearance of the individual groups of houses.

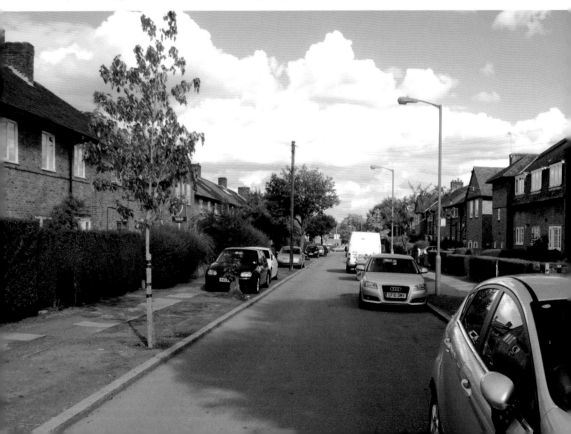

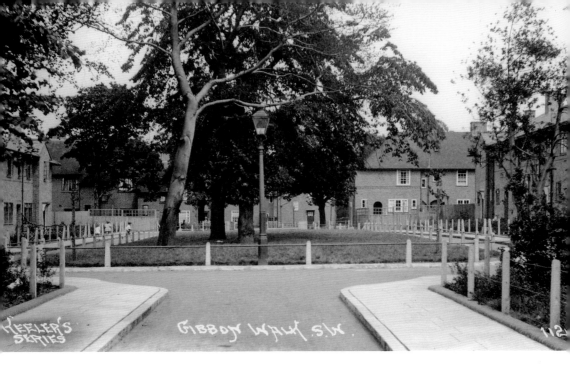

Gibbon Walk

Building started at the Upper Richmond Road and continued southwards. Gibbon Walk is an example of the efforts made to incorporate mature trees from the original parkland as well as planting new ones. The aim was that each group of houses would have an open, green space nearby. The layout of the estate was inspired by the garden city movement and evokes all the qualities of the town in the country. This has produced intimate clusters of cottages with their own individual identities. The road is named after the historian, Edward Gibbon, who was born in Putney.

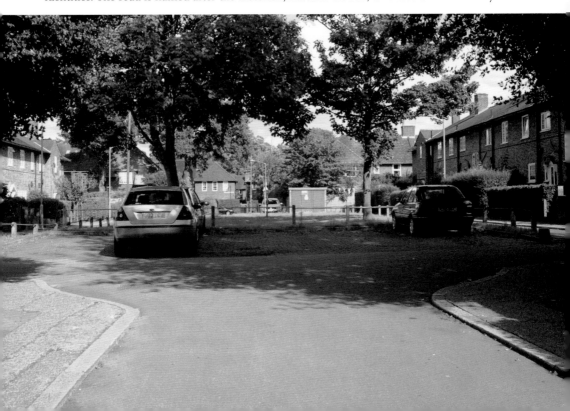

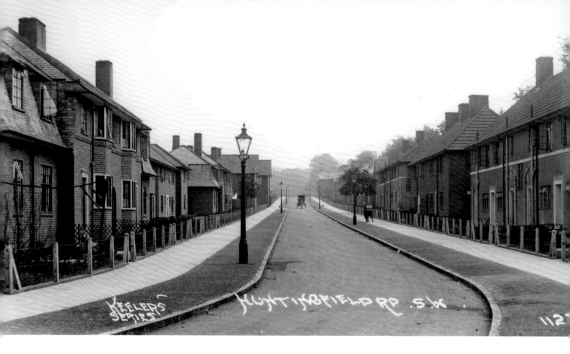

Huntingfield Road

Huntingfield Road shows there is also considerable variation in length of the roads on the estate. The original houses were lit by gas. Water was heated in a coal-fired boiler with a hand pump to get the hot water to the upstairs bathroom. This was a considerable improvement on most houses at the time. However, almost a century on the estate is less well designed for today's society of car owners.

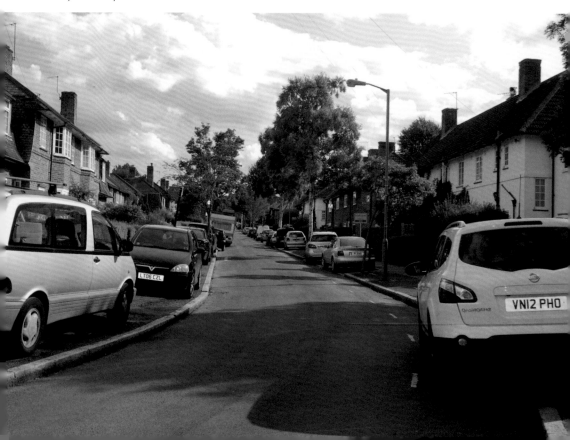

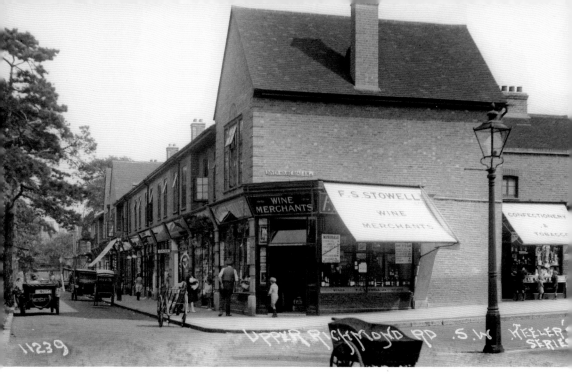

Stowell's Shop, Upper Richmond Road

The estate was designed to have its own facilities. The line of shops at the start of Dover House Road provided the usual shops such as bakers, dairy, grocers, tobacconist, sweetshop, laundry, greengrocer, butcher and general store. The estate also provided allotments and a school. But in the 1970s, some allotments, open space and a school were replaced by more housing.

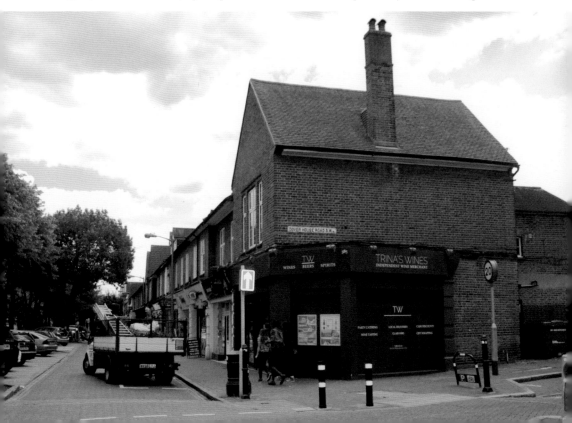

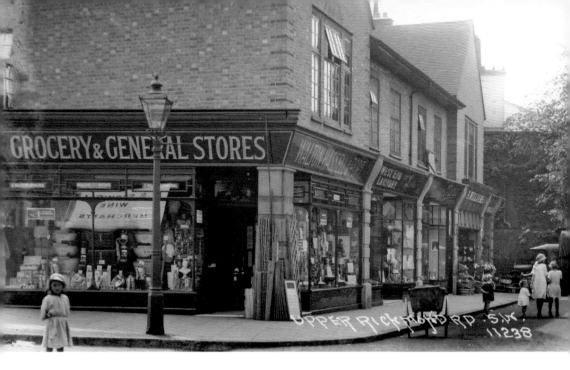

Walter, Hassell & Port Grocery Store, Upper Richmond Road

The shops continue on the other side of the Dover House Road. Walter, Hassell & Port was a provisions merchants or grocery stores founded in the nineteenth century with a total of seventy across the capital that operated until the late 1960s. Quality purveyors like this thrived on the estate because, as was customary at the time, the properties were let to people in secure jobs and with an income at least five times the total cost of rent, rates and fares. Public service workers were particularly likely to succeed in securing places.

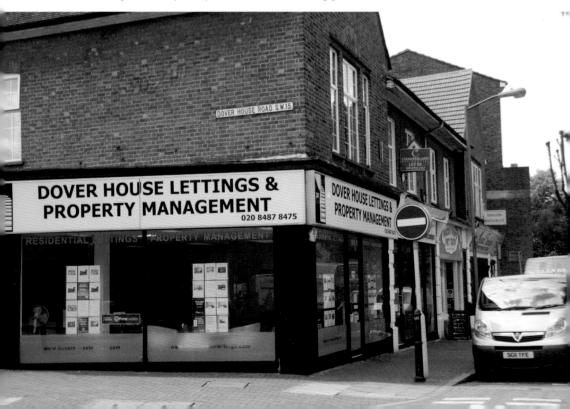

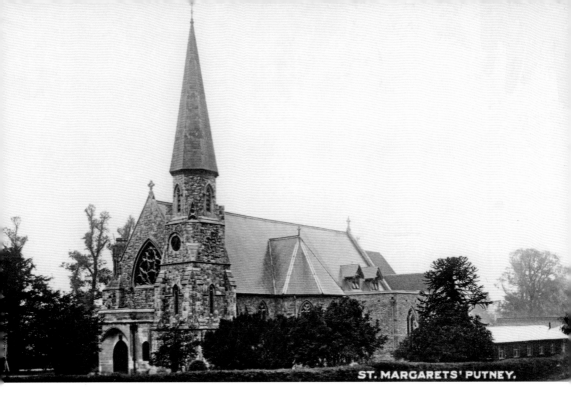

ST. MARGARETS' PUTNEY.

St Margaret's Church, Putney Park Lane
Granard Chapel was built in the nineteenth century for Baptist worship, and subsequently used by the Presbyterian church. It was donated in 1912 to Putney Church Council by the then resident of Granard House, Seth Taylor. The chapel was renamed St Margaret's, it is believed, after one of Taylor's daughters.

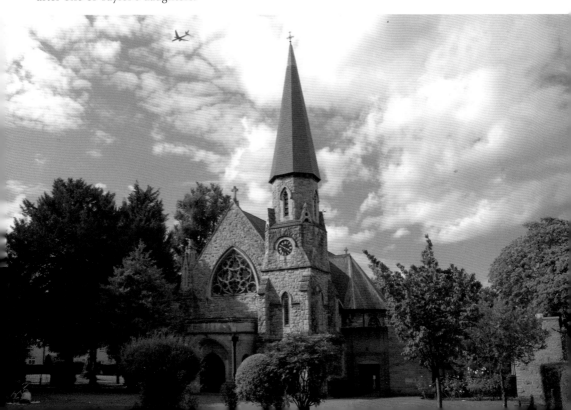

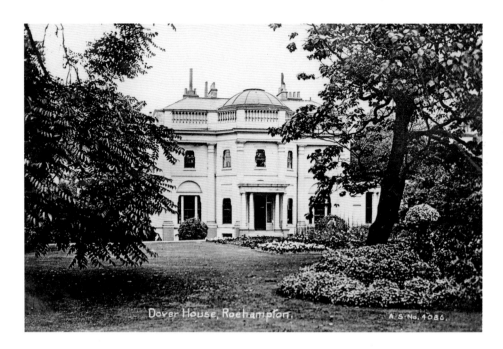

Dover House

Dover House was a country villa built in 1764 in forty acres of parkland. It was home to the Earl of Liverpool (a future Prime Minister) and the Lords Dover and Clifden, before being bought by the father of the American financier, J. Pierpoint Morgan Jr. It was used as a hospital during the First World War, and the military connection is highlighted by the message on the back of the postcard, dated 1915, mentioning 'night ops – am rather expecting a fire picket tomorrow'. The house was demolished in 1921 to provide land for the LCC's ambitious public housing development.

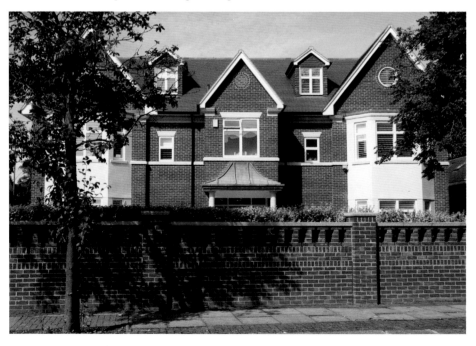

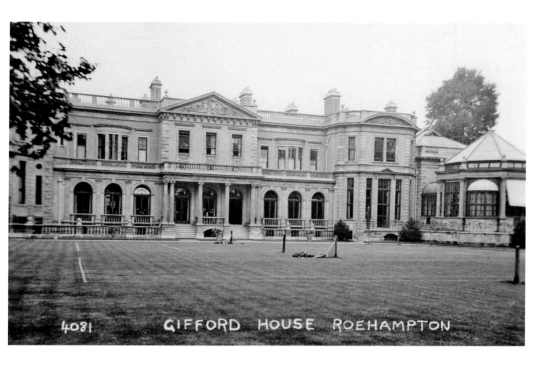

Gifford House

Gifford House was built in 1770 and from 1824 was the home of Robert, Baron Gifford, Attorney General and Crown prosecutor in both the Cato Street conspiracy and the Queen Caroline affair. In 1892, it was bought by the brewer J. D. Charrington, who commissioned the church architect, Fellowes Prynne, to renovate and enlarge the building. It was employed as a military hospital during the First World War, but was empty from 1933 until it was bought in the 1950s by the London Council to be the site of the Ashburton estate.

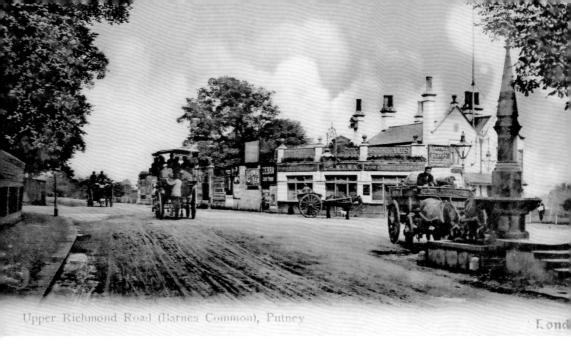

Upper Richmond Road (Barnes Common), Putney Lond

Upper Richmond Road at Roehampton Lane
One of Putney's northern boundaries runs along the Upper Richmond Road. The building in the centre of the picture is the Railway Hotel before it was renamed the Red Rover. The drinking trough on the right has long disappeared. Note that all the vehicles are pulled by horsepower.

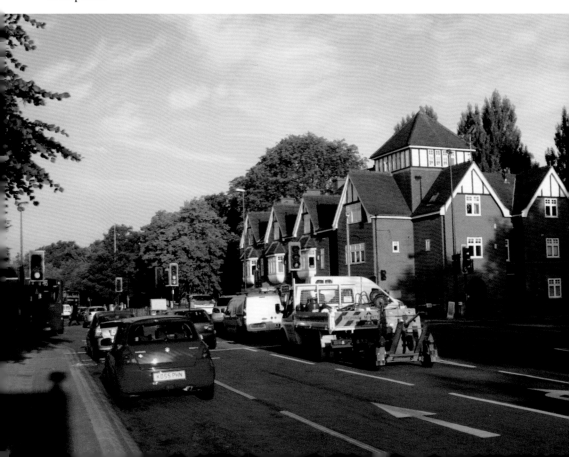

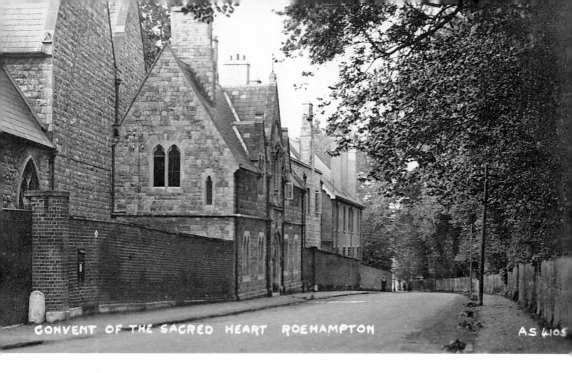

CONVENT OF THE SACRED HEART ROEHAMPTON

AS 6105

Convent of the Sacred Heart, Roehampton Lane
On the left is the chapel of the Convent of the Sacred Heart. The school was founded in London in 1842 and moved to Roehampton in 1850. During the Second World War, the school was evacuated and because of air raid damage moved to Marden Park, now known as Woldingham. The chapel is now part of Digby Stuart College.

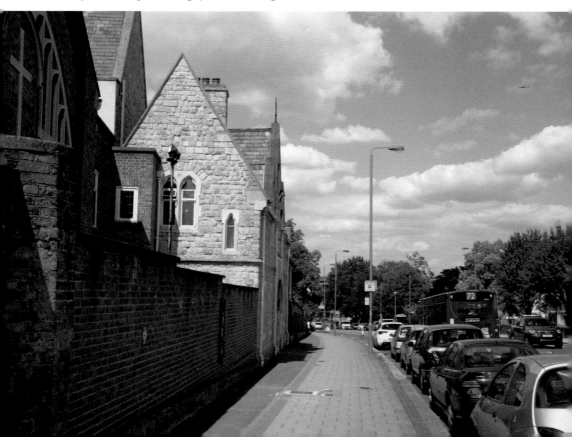

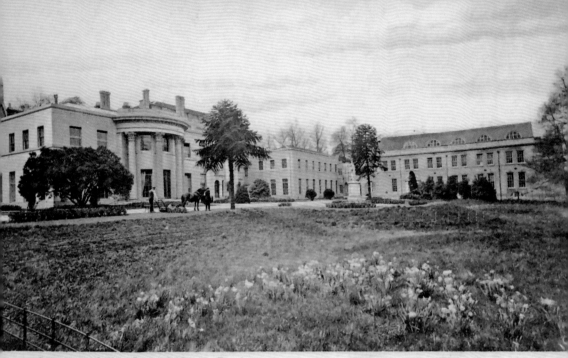

Convent of the Sacred Heart, Roehampton *From Retreat House*

Convent of the Sacred Heart, Roehampton University

A Huguenot builder, David Papillon, built several buildings in the Roehampton area in the early 1600s. His first one sold in 1622 and was later named Elm Grove. A later structure was built in *c.* 1796 for Benjamin Goldsmid, a wealthy banker. It was acquired by the Convent of the Sacred Heart in 1850, who turned it into a women's teacher training college in 1874. The building was completely destroyed by bombs in 1941.

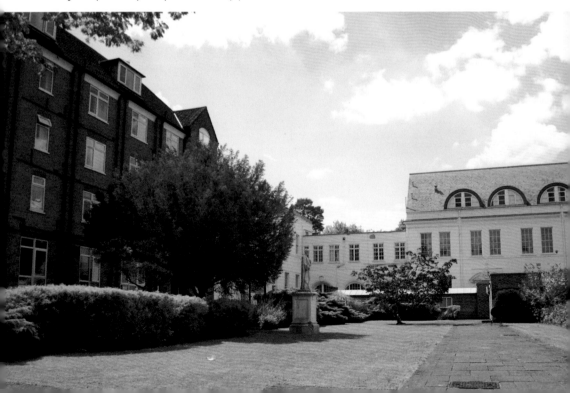

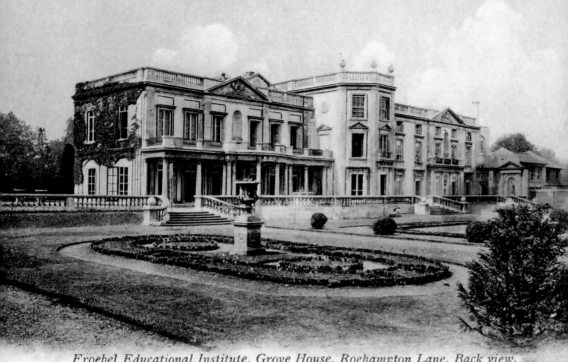

Froebel Educational Institute, Grove House, Roehampton Lane. Back view.

Froebel Institute, Grove House
The listed grounds of Grove House were first laid out in the eighteenth century. The institute was founded in 1892 as a college for teacher training by followers of Friedrich Froebel, who created the concept of the 'kindergarten'. Today, it is a college within Roehampton University and home to the university's department of education.

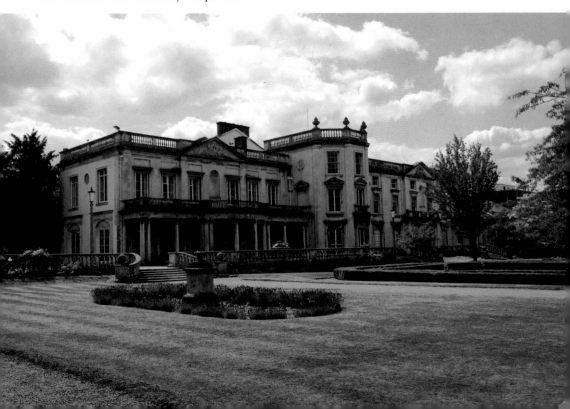

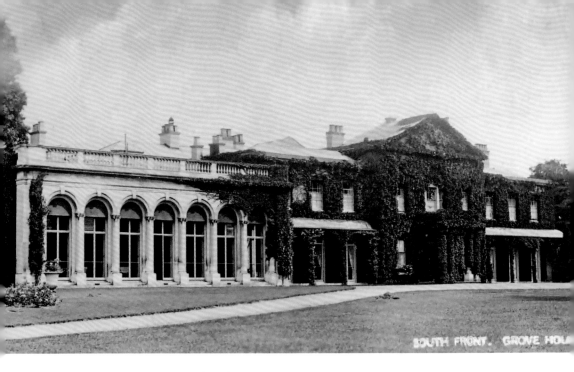

SOUTH FRONT. GROVE HOU

Grove House, Roehampton University
The Roehampton Great House was built in 1624. In 1777, Grove House was built on the site for Joshua Vannech, Baron Huntingfield, a successful merchant and later Member of Parliament. It was designed by James Wyatt. The house, with the pictures showing the south front, then became part of the Froebel College and is now part of the University of Roehampton.

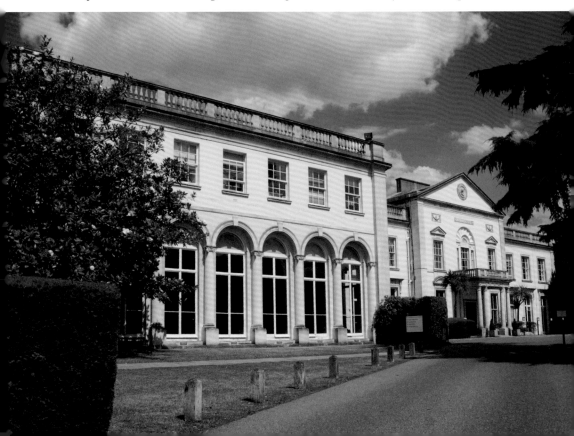

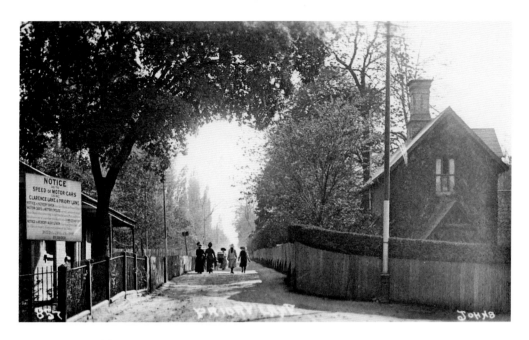

Priory Lane with Clarence Lane

Near the junction with Clarence Lane, we are looking northwards along Priory Lane. The sign of the left reads 'NOTICE is HEREBY GIVEN that these Roads are Private Property. MOTOR CARS & MOTOR CYCLES are only permitted to use these Roads when proceeding to and from Richmond Park and Private Residences and at a speed not exceeding the rate of 10 MILES an HOUR. DATED this 24th day of May 1907. BY ORDER'. Note that the road is not made up.

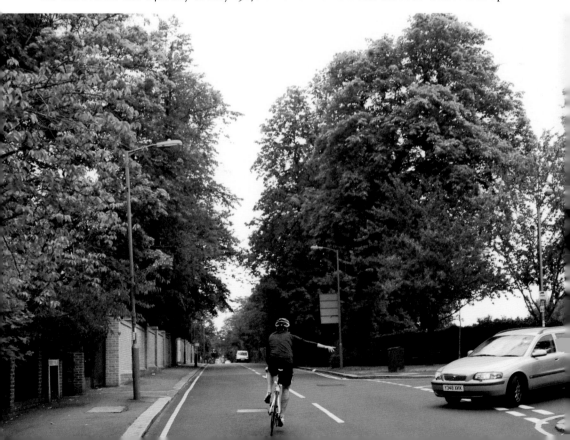

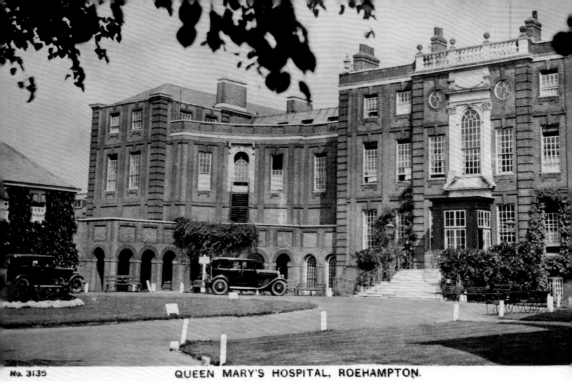

No. 3135 QUEEN MARY'S HOSPITAL, ROEHAMPTON.

Queen Mary's Hospital

Roehampton House was built in 1710-12 by Thomas Archer and was home to the Earls of Albemarle, and then Levin and Melville. Between 1910 and 1913, Sir Edwin Lutyens added the upper storeys to north and south wings over Archer's original ground floors. The house itself is Grade I listed and the wings Grade II listed. Queen Mary's Hospital opened in 1915 as a military hospital for servicemen who had lost limbs and a number of buildings sprung up in the grounds of the House. During the Second World War, the hospital specialised in the treatment of tropical diseases.

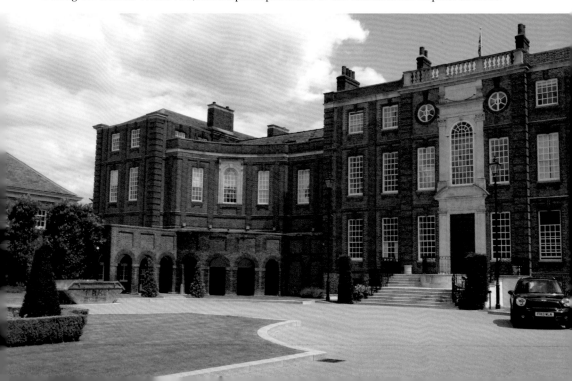

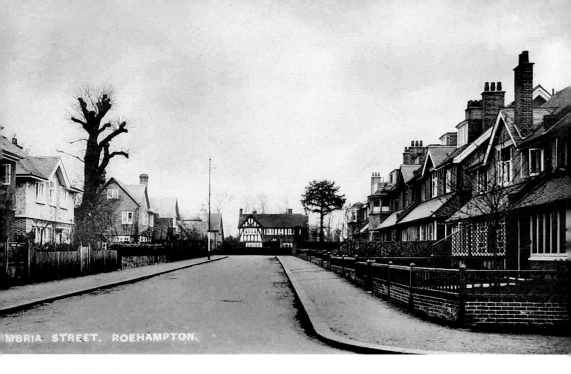

MBRIA STREET. ROEHAMPTON.

Umbria Street

Umbria Street, Akehurst Street, Rodway Road and Nepean Street were built between 1899 and 1915 on the site of the Spencer Lodge Estate. The site was developed by several different builders (as happened in other parts of Wandsworth). In 1906, *Tatler* magazine featured some of the newly built houses in Roehampton 'suited to those of moderate means'. A few houses have been added more recently.

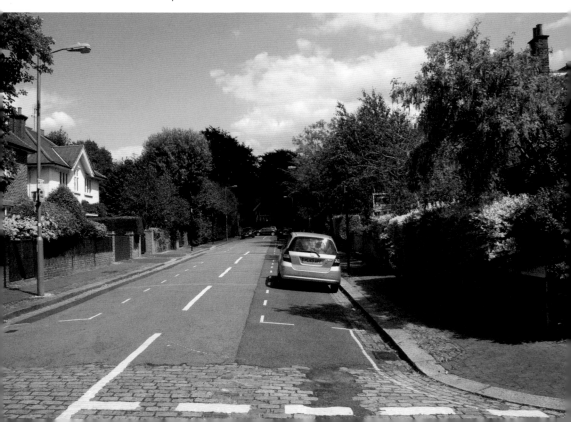

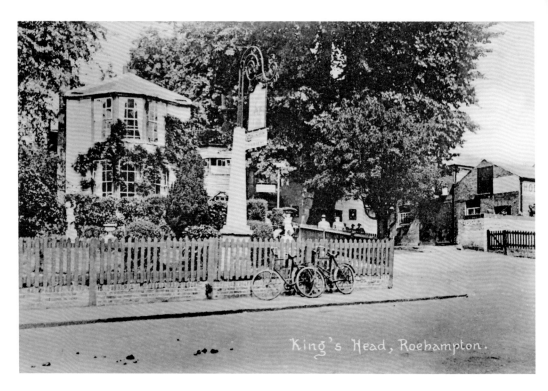

King's Head, Roehampton.

King's Head, Roehampton High Street

The site was part of the heath until the seventeenth century. The present building dates from at least the 1670s and is probably the oldest secular building in Wandsworth Borough. Originally called the Bull, the name was changed to the Kings Head in the 1770s, presumably in honour of George III.

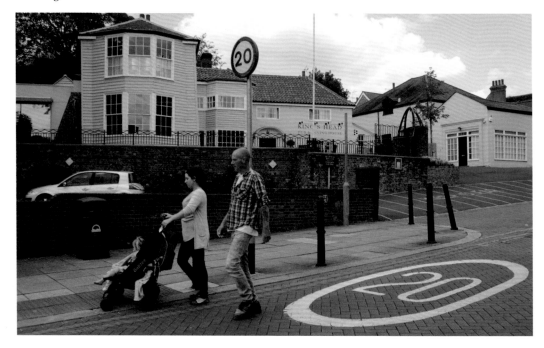

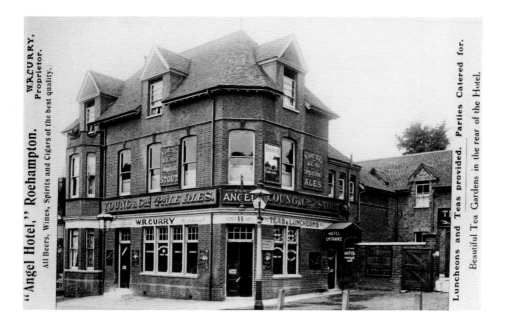

"Angel Hotel," Roehampton. W.R.CURRY, Proprietor. All Beers, Wines, Spirits and Cigars of the best quality.

Luncheons and Teas provided. Parties Catered for. Beautiful Tea Gardens in the rear of the Hotel.

Angel, Roehampton High Street

The pub claims to date from 1617, but as there were no inns in Roehampton at that time, the original Angel may have been in another part of Roehampton (inn names sometimes moved with the licensee). The name of this licensee – William Robert Curry – dates the picture above to *c.* 1920. Below, at the rear of the pub can be seen the residential Angel Mews, created from the former stables.

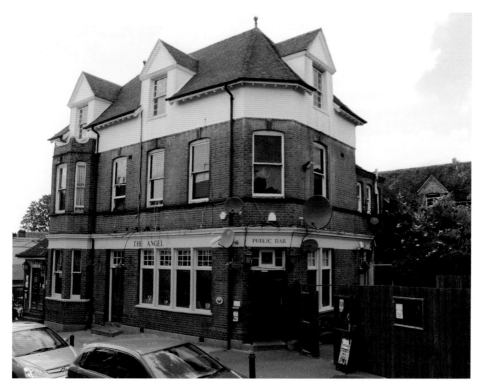

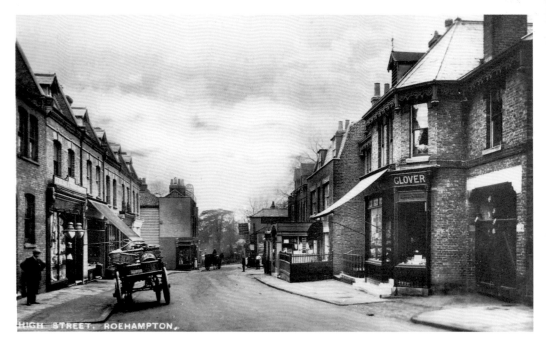

Roehampton High Street
No. 26 is a weatherboard property, typical of early, low-status houses in rural Surrey. Next to it is Blackford's Path where can be seen a typical nineteenth-century cast-iron bollard, round in section with pointed top and zig-zag collar detail. In 1986, the high street was extensively refurbished by Wandsworth Council.

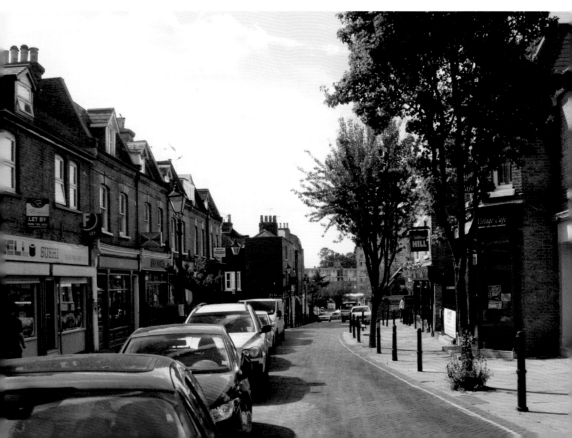

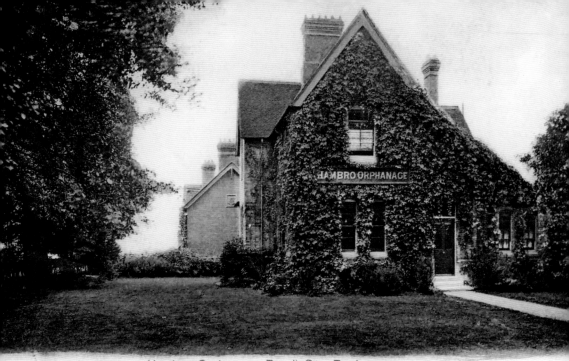

Hambro Orphanage, Trevill S<u>t</u>, Roehampton.

Hambro Orphanage, Trevill Street

The Hambro House Home was founded in 1879 to accommodate twenty-seven girls between the ages of four and eleven years and to train them for life in domestic service. In 1919, it was transferred to the Waifs and Strays' Society, the precursor of The Children's Society. The home closed in 1975 and is now a private house.

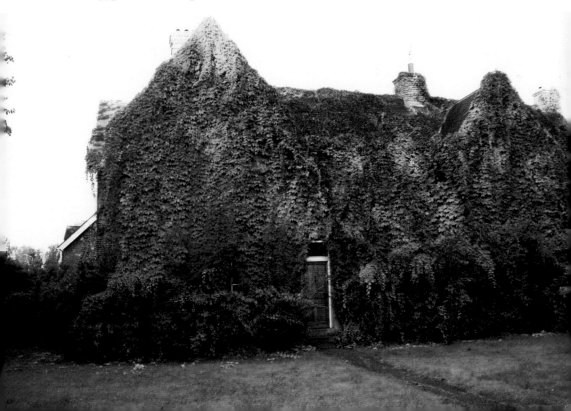

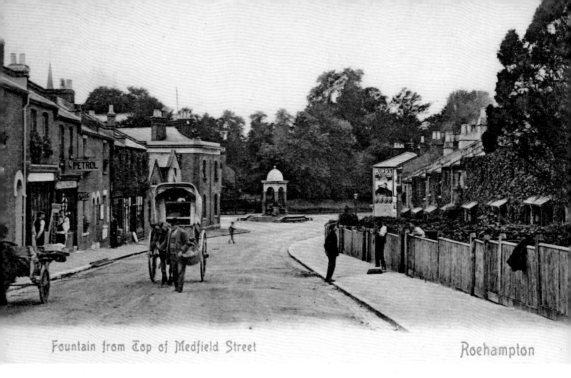

Fountain from Top of Medfield Street Roehampton

Cottages and Shops, Medfield Road

Medfield Street was first developed in 1862, with Stamford Cottages, followed by Ponsonby Road in 1863 and Elizabeth Place in 1870. At the bottom end of the street, as in the high street and Roehampton Lane, there is a series of shopfronts and some surviving eighteenth-century and early nineteenth-century buildings.

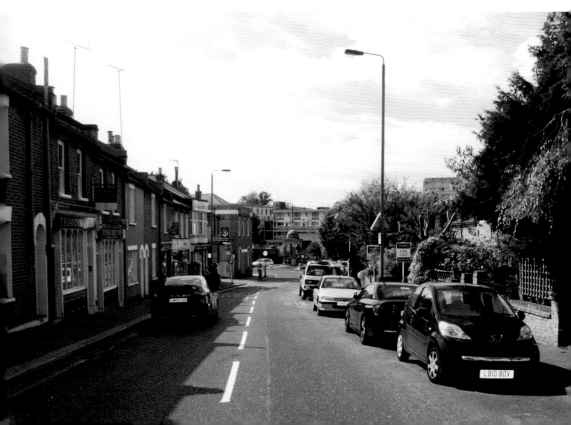

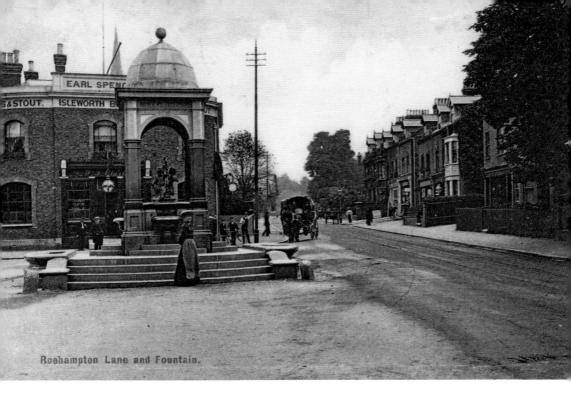

Roehampton Lane and Fountain.

Fountain, Roehampton Lane
The red and grey granite fountain was designed by J. C. Radford in 1882 and erected in memory of Lyne Stevens, MP, by his wife. The Earl Spencer pub in the background was named after the Lord of the Manor of Wimbledon, which also included Putney and Roehampton. It opened around the same time and closed as recently as 2004. Many of the village's original shops, which stood on the right, were demolished when Roehampton Lane was widened in the mid-1960s.

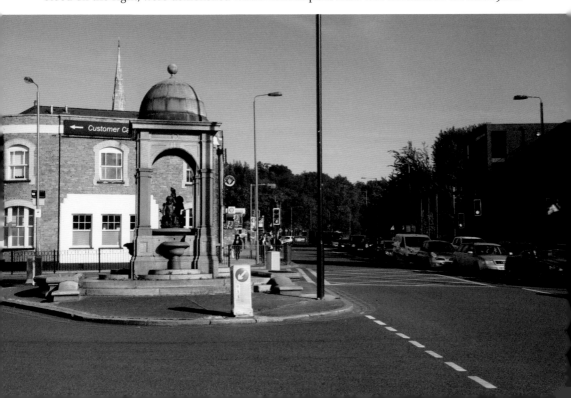

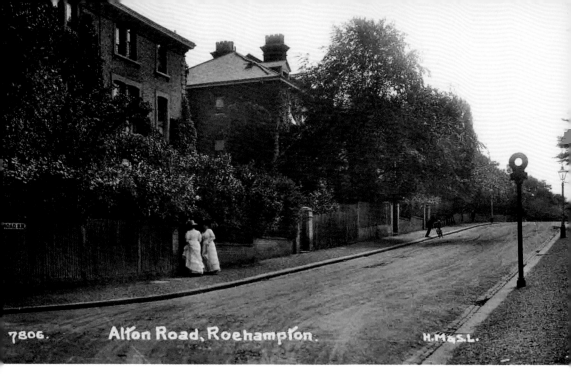

Alton Road with Roehampton Lane
The building on the left is a good example of the older houses that have survived demolition to make way for the Alton estate, an award-winning council housing estate built in 1960 by LCC. The demolition of many of the large houses dating from the late nineteenth century and their replacement by the Alton East (1952–55) and Alton West (1955–59) estates has dramatically changed the character of Roehampton from its earlier wealthy parkland estates into an area better known today for its social housing.

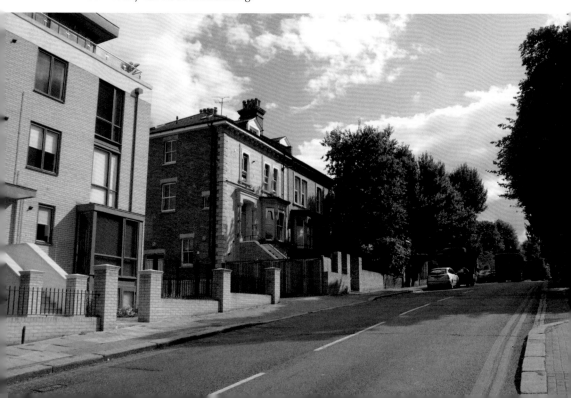

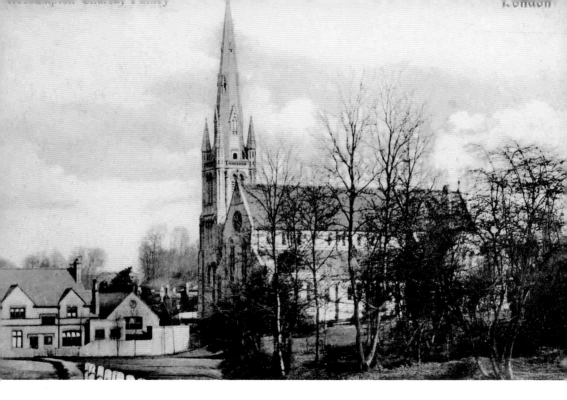

Roehampton Church

With its spire rising 230 feet above Roehampton Lane and set against the greenery of Putney Heath, Holy Trinity parish church remains a striking local landmark in the face of the tower blocks of the Alton Estate opposite. It was designed by George Fellowes-Prynne and built of ragstone with Bath Stone dressings in 1896–98. The school came much earlier.

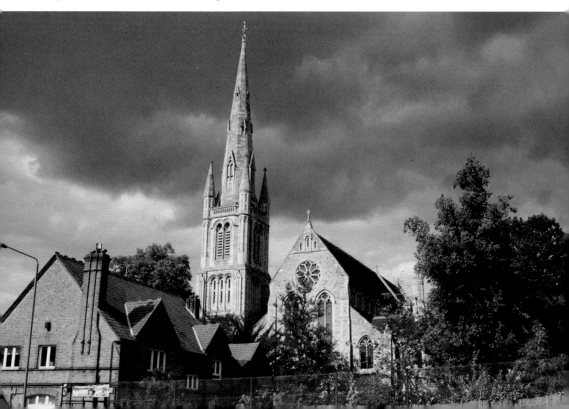

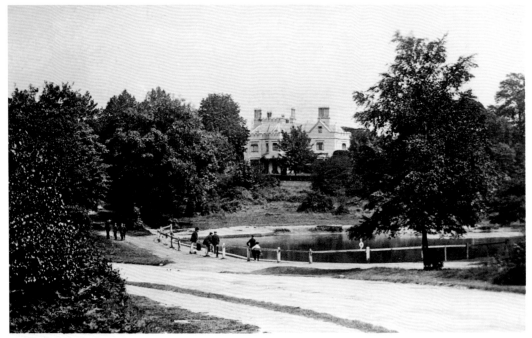

No. 1161. WIMBLEDON COMMON:—SCIO POND.

Scio Pond, Putney Heath

Scio House was built by a Greek merchant and named after his birthplace, the island of Chios. It eventually became a hospital for officers and has since been redeveloped as a gated community of seventy neo-Georgian homes. Scio Pond lies below the house next to the disused portion of the old Portsmouth Road, popular with dog walkers and herons alike.

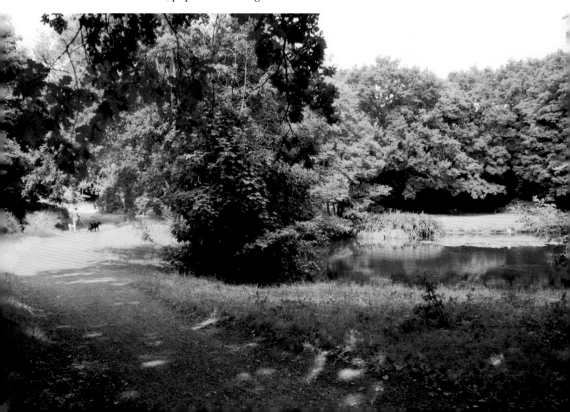

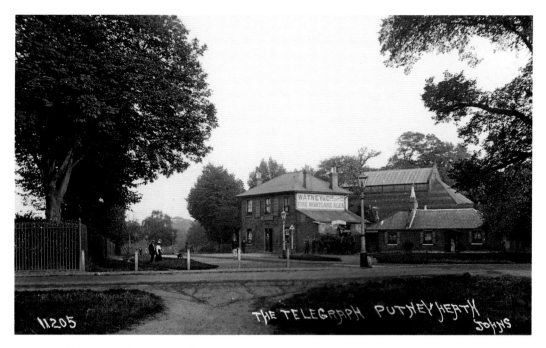

The Telegraph, Putney Heath

To help defend against a possible invasion by revolutionary France, a chain of ten shutter telegraph stations was installed between London and Portsmouth in 1796. Because of its elevation 45 m (148 feet) above sea level, Putney Heath was chosen as the site for one of these. The telegraph station closed in 1847, but the pub that was built beside it fourteen years later has retained the association ever since.

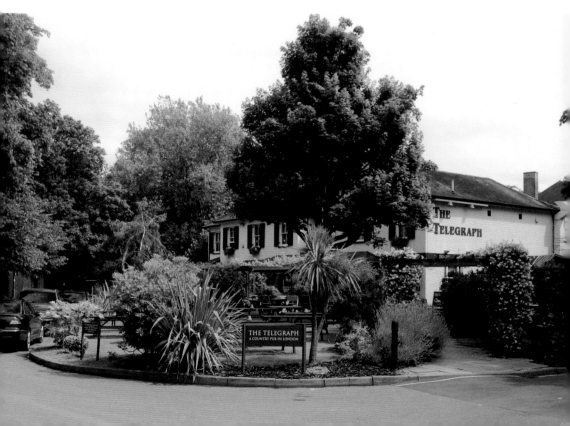

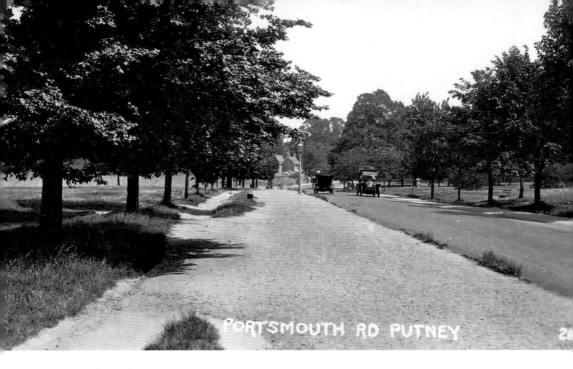

PORTSMOUTH RD PUTNEY

Portsmouth Road

At one time, Putney Bridge was the only crossing of the Thames between Kingston and London, making it one of the most direct routes to the capital for travellers from the south and southwest. Until the middle of the twentieth century, Portsmouth Road was the only road across Putney Heath between Kingston Road (what is now the A3) and Putney Hill. Today, the top of the road detours eastwards past the Telegraph Pub before completing its journey along Wildcroft Road, leaving the original a quiet avenue across the heath.

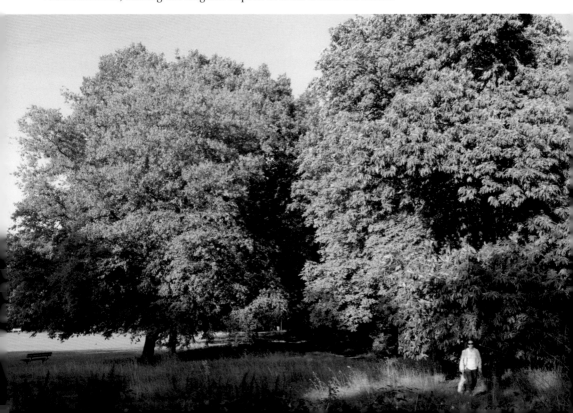

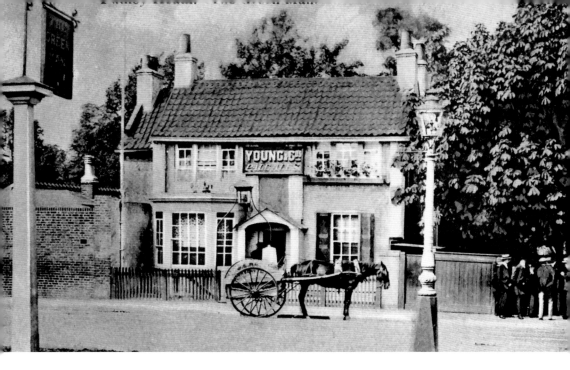

Green Man, Putney Heath

Dating back to around 1700 and standing on the edge of Putney Heath, the Green Man has understandably become mired in myths. Some relate to highwaymen who frequented the heath, preying on luckless travellers. More surprising are the duels that actually took place there. On 27 May 1798, the then Prime Minister, William Pitt, fought a bloodless battle with another MP, William Tierney. Less fortunate was another future Prime Minister, George Canning, who fought a duel on the heath with a fellow member of the Cabinet, Lord Castlereagh, in 1809. After both first shots missed, Canning's second was deflected by a button on Castlereagh's coat, before Castlereagh shot him in the thigh. Honour satisfied, Castlereagh helped Canning limp away!

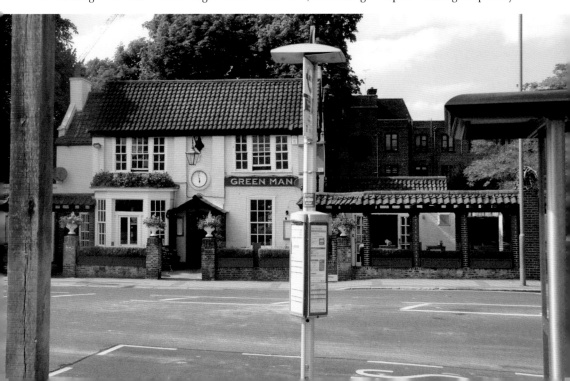

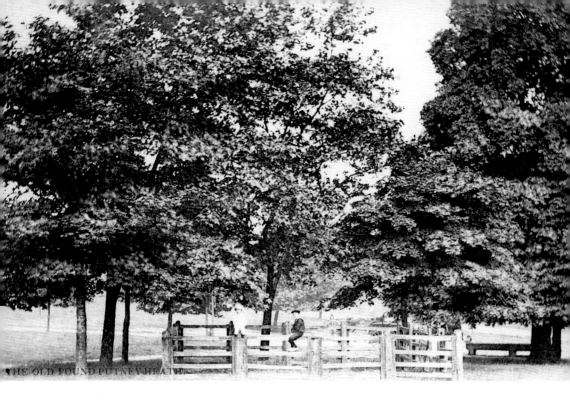

THE OLD POUND PUTNEY HEATH

Cattle Pound, Putney Heath
Opposite to the Green Man and just near the bus terminus, a wooden-fence cattle pound stands half-hidden beneath two large plane trees. Originally built in the nineteenth century and as a pen for straying livestock found on the heath, the pound has been a Grade II-listed structure since 1983.

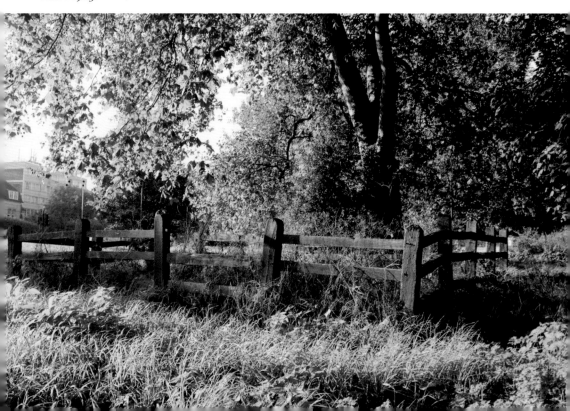

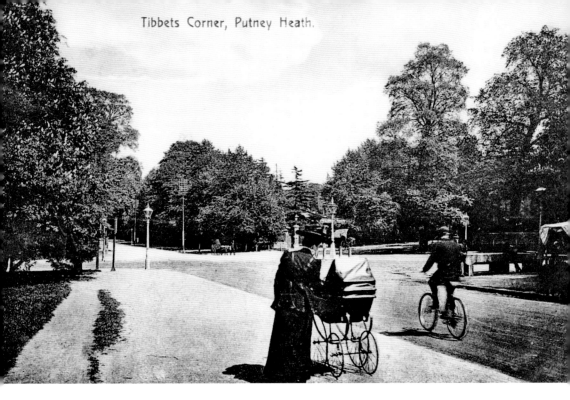

Tibbet's Corner

The original image was taken in around 1910 and looks towards West Hill and Wandsworth. At the junction to the right are the three roads, Princes Way, Victoria and Park Side, which lead towards Wimbledon past the splendid and very large detached houses that edge Wimbledon Common. In spite of the ominous rhyme with 'gibbet', Tibbet was actually the name of a gatekeeper employed on Lord Spencer's estate nearby.

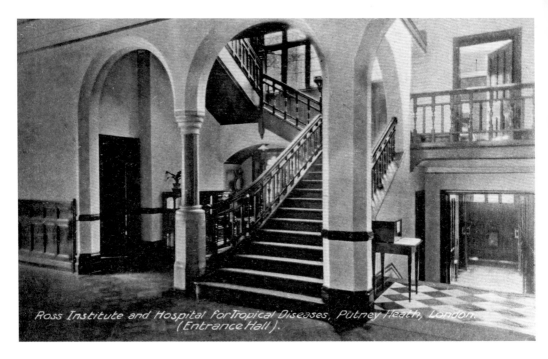

Ross Institute and Hospital for Tropical Diseases, Putney Heath, London. (Entrance Hall).

Ross Institute, Putney Hill

Sir Ronald Ross was awarded the Nobel Prize in 1902 for his discovery that malaria was transmitted by mosquito. The Ross Institute was opened in 1926 for the study of the nature and treatment of tropical diseases at Bath House at the top of Putney Hill. In 1932, the institute was incorporated into the London School of Hygiene and Tropical Medicine, and the building was later demolished to make way for a block of flats. Traces of the magnificent old building can still be found among its foundations, apparently, but the only visible sign above ground today is its name, Ross Court.

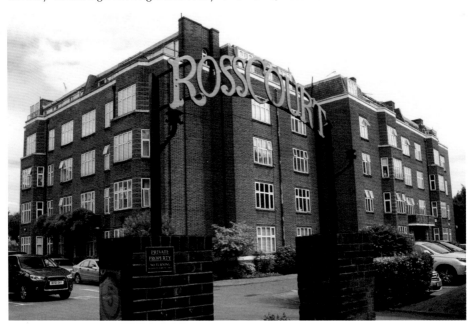

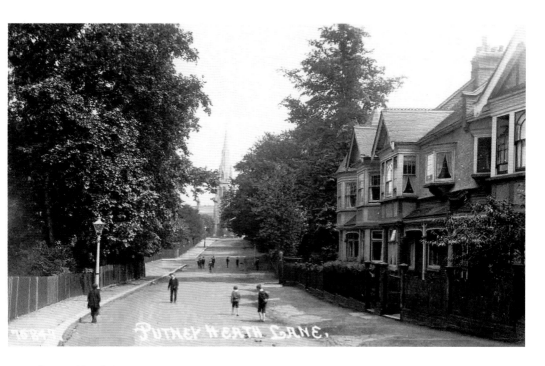

Putney Heath Lane

Relatively little seems to have changed in Cut Through Lane, as it used to be known. It is surprisingly peaceful, too, with the parked cars, the only clue that at each end of the lane are the busy thoroughfares of Putney Hill and West Hill. Like its namesake in Roehampton Holy Trinity church, on West Hill, is a prominent local landmark. The church was built in 1872, and the spire added in 1888.

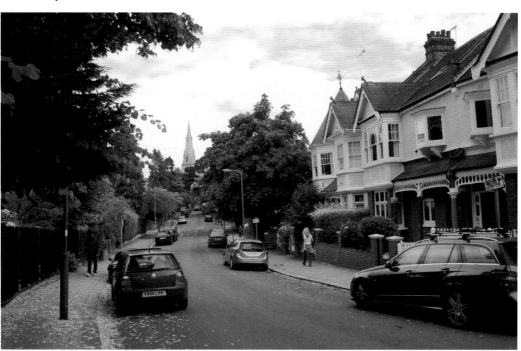

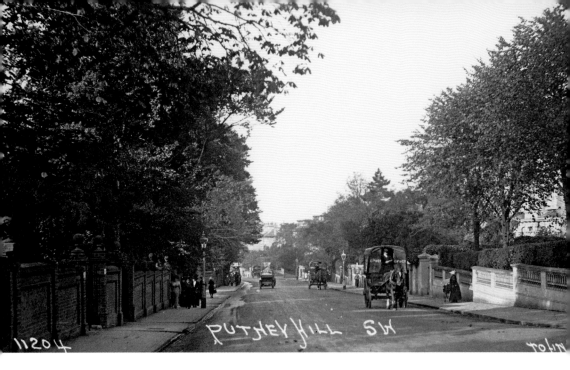

Putney Hill above Cambalt Road
Putney Hill, although not steep, is over a mile long. The Trace Horse Fund, a small charity based at the foot of the hill, provided an extra horse to assist with heavy loads. Most of the boundary walls by the pavements have disappeared, but those on the left-hand side of the road are still in place.

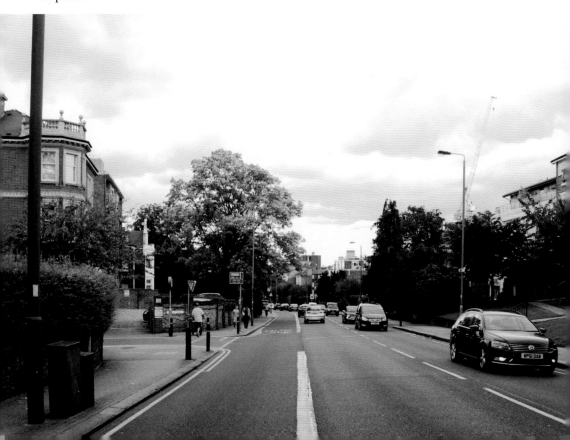

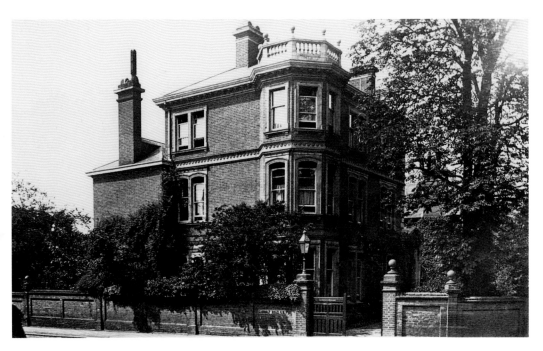

Cambalt Road

This house on the corner of Cambalt Road was once typical of the large family homes that lined Putney Hill. In around 1920, this particular building was acquired for the Leinster House School. Since then, it has been extensively extended at the rear and converted into private flats.

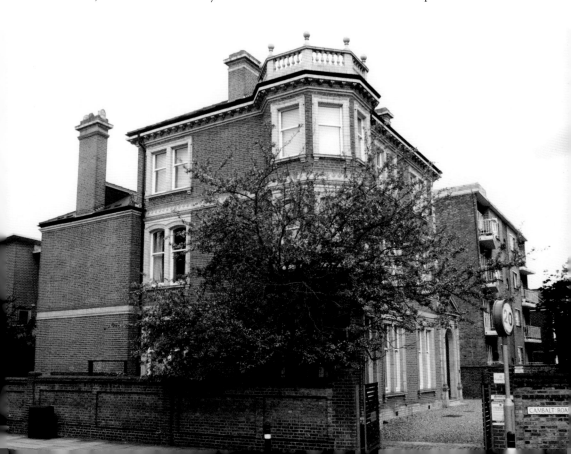

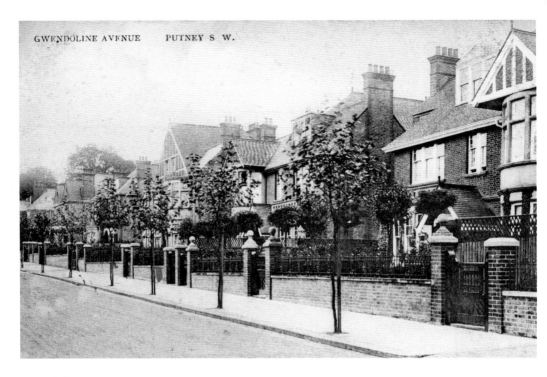

GWENDOLINE AVENUE PUTNEY S W.

Gwendolen Avenue

Built on agricultural land, by the early 1890s the avenue was laid out with the earliest buildings at the northern end (Upper Richmond Road, close to the Wesleyan Church). Those in these pictures are further up the hill towards the southern end. The attraction of the houses is all the greater with the large spaces between the buildings.

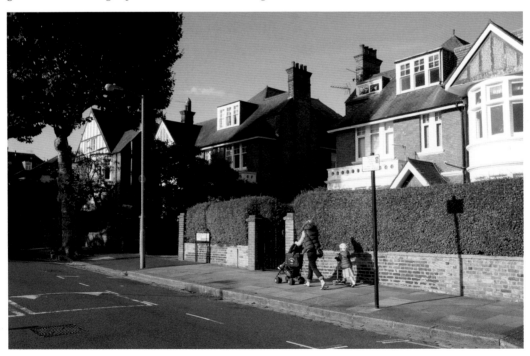

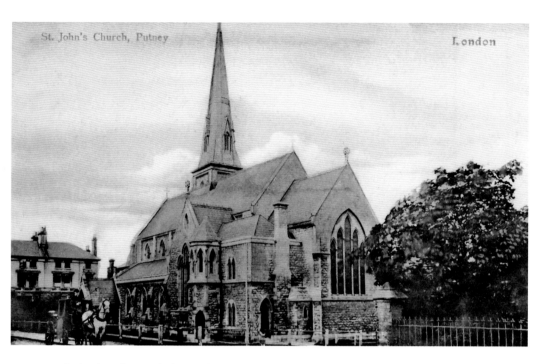

St John's Church, St John's Road

The Anglican church was built in 1859, in a plain thirteenth-century style. It was extended several times with a final seating capacity of 350. It was declared redundant in 1977 and the freehold sold to the Polish Catholic church in 2007. The proceeds of the sale went to rebuilding St Mary's church following the arson attack in 1973.

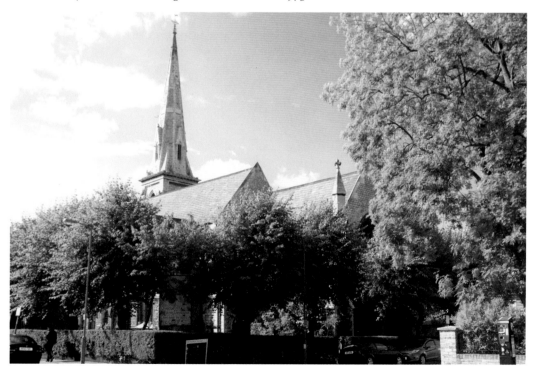

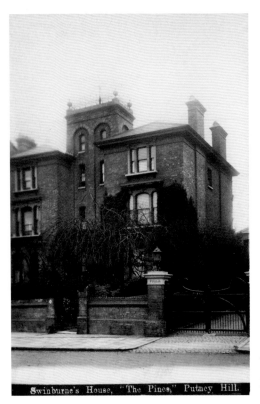

Swinburne's House, "The Pines," Putney Hill.

Swinburne's House

The blue plaque on the wall of The Pines at the bottom of Putney Hill was erected by the LCC in 1926 and reads: 'Algernon Charles Swinburne (1837–1909) poet, and his friend Theodore Watts-Dunton (1832–1914) poet, novelist, critic, lived and died here'. The house was built in around 1870 and is Grade II listed.

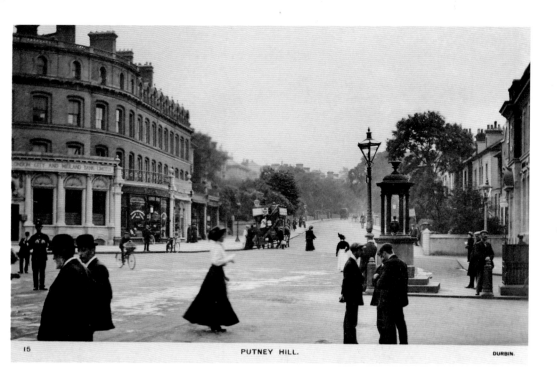

15 PUTNEY HILL. DURBIN.

Lower Putney Hill with Upper Richmond Road

The postcard above has no date of posting, but it was sent to New York by a visiting American. She draws attention to the omnibus she uses to 'ride up to London right in the centre of the city. This one is drawn by a horse but most all of them are run by gasoline same as any motor'.

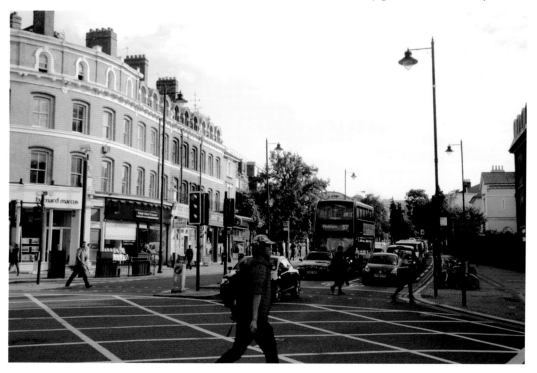

About the Authors

Simon lived for twenty years in the Battersea area, where he was a frequent public speaker on local history and Deputy Editor of the *Wandsworth Historian*, the much-respected journal of the Wandsworth Historical Society. He also served both the London and Middlesex Archaeological Society's Council and Greater London Local History subcommittee. Simon has published two books, a DVD and several articles about aspects of local history in the area. He has an Advanced Diploma in Local History and is currently studying PhD in History at the University of Cambridge.

Ron Elam is a well-known local historian. He has collected many thousands of views of the streets of London showing life in the early years of the 1900s. His speciality is the areas of inner south and south-west London. He also has a considerable number of pictures of many other parts of Greater London.

Image Credits

All old images are from the collection of Ron Elam.

All modern images were taken by Simon McNeill-Ritchie (except the modern images on pages 18 and 34, provided by David and Victoria Nicholson and Ron Elam, respectively).